Yvonne Rainer

*The Mind is a Muscle*

Catherine Wood

*One Work* Series Editor
Mark Lewis

Afterall Books Editors
Charles Esche and Mark Lewis

Contributing Editor
Jan Verwoert

Managing Editor
Caroline Woodley

Picture Research
Gaia Alessi

Copy Editor
Tavia Fortt

Other titles in the *One Work* series:

*Bas Jan Ader: In Search of the Miraculous*
by Jan Verwoert

*Hollis Frampton: (nostalgia)*
by Rachel Moore

*Ilya Kabakov: The Man Who Flew
into Space from his Apartment*
by Boris Groys

*Richard Prince: Untitled (couple)*
by Michael Newman

*Joan Jonas: I Want to Live in the Country
(And Other Romances)*
by Susan Morgan

*Mary Heilmann: Save the Last
Dance for Me*
by Terry R. Myers

*Marc Camille Chaimowicz:
Celebration? Realife*
by Tom Holert

*Fischli and Weiss: The Way Things Go*
by Jeremy Millar

*One Work* is a unique series of books published by Afterall, based at Central Saint Martins College of Art and Design in London. Each book presents a single work of art considered in detail by a single author. The focus of the series is on contemporary art and its aim is to provoke debate about significant moments in art's recent development.

Over the course of more than 100 books, important works will be presented in a meticulous and generous manner by writers who believe passionately in the originality and significance of the works about which they have chosen to write. Each book contains a comprehensive and detailed formal description of the work, followed by a critical mapping of the aesthetic and cultural context in which it was made and has gone on to shape. The changing presentation and reception of the work throughout its existence is also discussed and each writer stakes a claim on the influence 'their' work has on the making and understanding of other works of art.

The books insist that a single contemporary work of art (in all of its different manifestations) can, through a unique and radical aesthetic articulation or invention, affect our understanding of art in general. More than that, these books suggest that a single work of art can literally transform, however modestly, the way we look at and understand the world. In this sense the *One Work* series, while by no means exhaustive, will eventually become a veritable library of works of art that have made a difference.

First published in 2007
by Afterall Books

Afterall
Central Saint Martins
College of Art and Design
University of the Arts London
107—109 Charing Cross Road
London WC2H ODU
www.afterall.org

ISBN Paperback: 978-1-84638-037-2
ISBN Cloth: 978-1-84638-038-9

Distribution by The MIT Press, Cambridge,
Massachusetts and London
www.mitpress.mit.edu

Art Direction and Typeface Design
A2/SW/HK

Printed and bound by
Die Keure, Belgium

Yvonne Rainer
# *The Mind is a Muscle*

Catherine Wood

I would like to express my gratitude to Yvonne Rainer for patiently answering my queries, both now and when I began research on her work as a postgraduate student ten years ago. Thanks are due also to Mao Mollona, Pablo Lafuente, Briony Fer and Silke Otto-Knapp for advice, conversation and inspiration on the book's content and themes. I gratefully acknowledge the help I received from Dr. Susan M. Allen, Virginia Mokslaveskas and Glenn Phillips at The Getty Research Institute, and the generosity of the Getty Foundation for an invaluable research opportunity looking into the fascinating holdings in Rainer's archive. I would also like to thank Carrie Lambert-Beatty for sharing her manuscript with me and Barbara Moore for providing photographs from the Peter Moore archive.

The author and editors would also like to thank Maureen Paley for her kind support of this publication and associated events.

Catherine Wood is Curator of Contemporary Art and Performance at Tate Modern where she has presented performances by artists including Trisha Brown, Pablo Bronstein, Marc Camille Chaimowicz, Guy de Cointet, Linder and Daria Martin. She recently curated 'Actions and Interruptions', a programme of live interventions in the museum, and co-curated, with Jessica Morgan, the exhibition 'The World as a Stage'. She is on the curatorial advisory board for Performa, New York and has regularly published articles in *Afterall*, *Art Monthly*, *frieze*, *Untitled* and contributed numerous essays to exhibition catalogues.

For A.

1. Picture the Scene

2. Anybody and Everybody

3. Scripts

4. The World as a Stage

5. 'Ne Travaillez Jamais!'

6. A Flourish: The Economy of *Trio A*

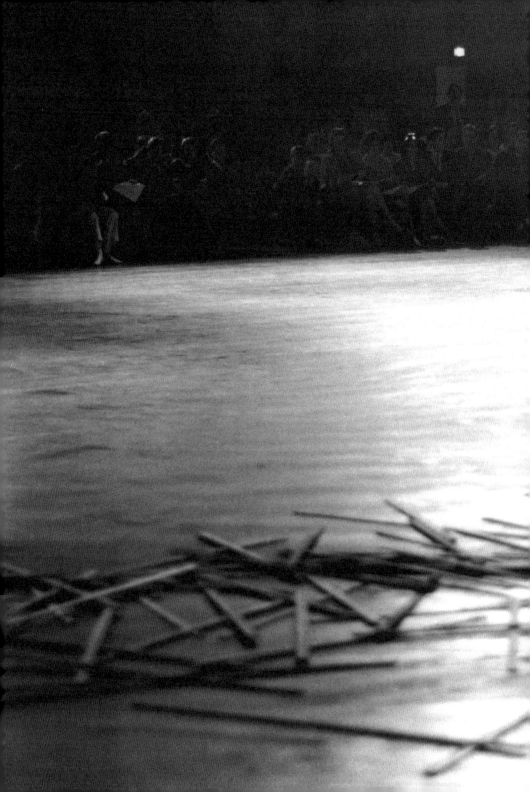

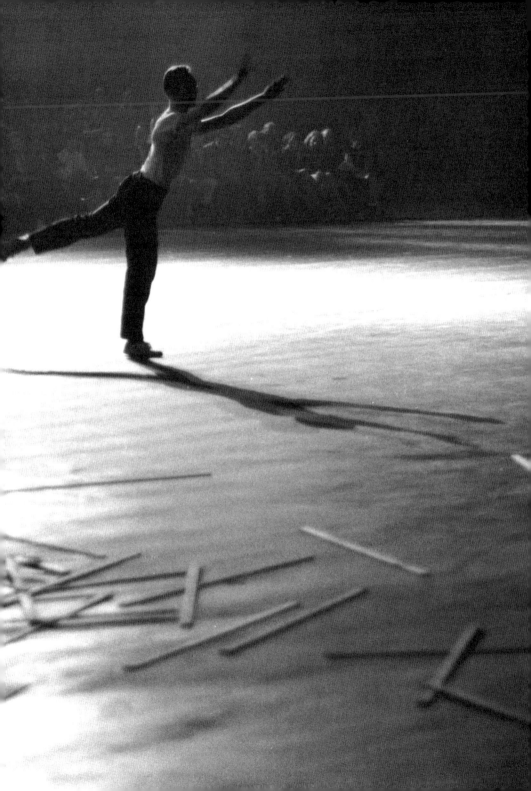

previous page

*Lecture*, Judson Church, New York,
1966. Peter Saul solo.
Photograph by Peter Moore.

## 1. Picture the Scene

### People

Picture Yvonne Rainer's 'evening-length work', *The Mind is a Muscle* (1968), not via the inventory of fragments that testify to it as a historical fact — black-and-white photographs, diagrams, descriptive notes, reviews, lists of names — but as a live event. Picture a gathering of people within a theatre building. Of these people, seven are on the stage while the rest sit facing them in their seats.[1] Then picture this congregation of performers and audience members within the theatre, numbering approximately 200 in total,[2] as one particular, ritual configuration of bodies, positions and actions within the multiplicity of bodies, positions and actions to be found among the 18 million inhabitants of New York City at that time — themselves among the then over 201 million citizens of the United States, and an estimated three-and-a-half billion people across the surface of the planet.[3]

I begin with this picture of the urban field in mind to figure *The Mind is a Muscle*'s medium — dance — as the simplest and most economical meeting point between behaviour and aesthetics. In this picture, its specialised language is just one kind of physical activity among the vast range of activities people would have been carrying out in parallel with the performance in question. Perhaps, as Rainer imagined in a diary entry in 1952, they were, 'sleeping, awaking, dressing, eating, crapping, working, copulating, bathing',[4] among other things. The repetitions,

patterns and gestures of *The Mind is a Muscle* appear here as a small section of activity in an expansive field of human action. It is from such a viewpoint that Rainer's conception of 'ordinary dance' as it was situated within the realm of everyday life begins to come clear.

This book is about the significance of the gestures, movements and positions repeated and made visible as a performance at the Anderson Theater titled *The Mind is a Muscle* by those seven people in April 1968, in a situation that lasted for approximately one hour and 45 minutes. It is also about the legacy of this event, both conceptually and through its reproduction via teaching and performance in the years since then. Although it is useful to refer to the curious, hieroglyphic documentation that exists,[5] I do not want those pictures to become the focus of investigation in themselves, to mask or block our imaginative understanding of how the event operated at the time, and how it has been transmitted as live knowledge since. I wish to consider the temporary crystallisation of this particular aesthetic, its form as culture in dynamic production and transmission, and its inherent ephemerality as essential constituents of its meaning.[6] *The Mind is a Muscle* need not be straightforwardly labelled as 'dance' or 'art', but should be understood as an attempt at a technically crude and conceptually complex form of image-making for an audience that was actively present. Using the physical and conceptual frames of the theatre as a model of community, Rainer staged the process of cultural creation in action and so addressed,

with a view to potentially changing, the social conditions of agency and experience.

**The Work**

As the surviving programme and accompanying statement attest, the complete version[7] of *The Mind is a Muscle* premiered at the Anderson Theater, which was located on Second Avenue in the East Village, New York, on 11, 14 and 15 April 1968. Like *Terrain* (1963) and *Parts of Some Sextets* (1965), this was a multi-part work authored solely by Rainer. Coming toward the end of a decade that had witnessed such rich experimentation in dance for Rainer and her peers, it presented perhaps the fullest singular summation of her choreographic project to date. In the statement, Rainer described her 'overall concern' as it was manifested in this piece: to strip dance movement of 'super stylisation' in order to 'reveal people as they are engaged in various kinds of activities — alone, with each other, with objects'. She aimed rather 'to weight the quality of the human body toward that of objects' and to foreground 'Interaction and cooperation on the one hand; substantiality and inertia on the other.'

If this work was the most structured and 'complete' work that she had made so far, Rainer's activities during the years before and after its presentation at the Anderson demonstrate that it was also an anchor point in the midst of an important moment of transition. She had begun making short 8mm and 16mm films framing simple actions with *Hand Movie* (1966), then *Volleyball* (1967); the latter was projected during

the *Film* section of *The Mind is a Muscle*. In 1968, she began to work in what she called a composite 'format', with pieces such as *Performance Demonstration* beginning to involve the performance of teaching onstage, which would lead in turn to the open-ended and participatory nature of *Continuous Project Altered Daily* (1969—70) and *The Grand Union* (1970). The former visibly incorporated rehearsal and process into performance and fed into the creation of the latter, a collective whose activities were generated through improvisation and structured by shifts in leadership between Rainer and fellow members who included Steve Paxton, Trisha Brown and David Gordon.

*The Mind is a Muscle* combined some new work with pieces that had been tested in performance already, including a number of variations built from Rainer's most well-known dance sequence, *Trio A* (fig.1). *Trio A* has served as a kind of backbone to Rainer's dance practice since it was first performed as *The Mind is a Muscle, Part 1* at the Judson Church in 1966. The approximately four-and-a-half minute piece (its exact timing depends on who is performing it) comprises a sequence of movements that are without phrasal segmentation and so appear to be continuous in motion, without still moments of registration. The choreography persists in a perpetually unpredictable manner, deliberately refusing familiar dance patterns that rest upon arcs of development and climax. Such was the significance of *Trio A* that Rainer reported in an interview with Wendy Perron in 1981 that she had, for a certain time, used it as a kind of self-test mechanism,

practicing it in her studio every single day.[8] Other parts of the programme — such as *Lecture*, a version of *Trio A* danced by Rainer in tap shoes that had been featured in the 'Now' festival in Washington, D.C. in April 1966 and *Mat*, which was conceived by Rainer in the autumn of 1967 while in hospital with an intestinal illness — were performed early in 1968 by William Davis and Becky Arnold. The dancing was for the most part presented in silence, with music only occurring in the 'interludes' between acts.

The programme sheet (figs.2 — 3) for *The Mind is a Muscle* lists the sequence of the evening's events beginning with *Trio A*, followed by its variation in *Trio B* (figs.4 — 5), then *Mat*, *Stairs* and *Act* (figs.6 — 7) before a conventional, theatre-style intermission. The second half began with a series of aural interludes, as had punctuated the gaps between dances in the first half, and continued with *Trio A1*, *Horses*, *Film* and finally *Lecture*, a variation on *Trio A* (figs.8 — 10). Rainer specified that all seven performers — Becky Arnold, William Davis, Gay Delanghe, David Gordon, Barbara Lloyd, Steve Paxton and herself — should remain onstage throughout the duration of the concert, performing the role of onstage audience while they were not dancing. An eighth performer, magician Harry De Dio, appeared only in *Act*.

The dimensions of the physical setting in which the dancers performed at the Anderson Theater are described in Rainer's 1968 notebook:

40' proscenium width
35' deep
17' high
screen 8'x6'

The event, stripped of familiar signifiers in the form
of titles and names, might best be described in the
language of a theatre script:

THE SET
For the opening scene: the stage stripped bare but for a
large, highly reflective wall of Mylar[9] stretching from
wing to wing and floor to flies. For subsequent scenes:
a foam rubber mat, a dumbbell, bubble-wrap, a block-set
of steps, wooden slats and a flown grid.

THE PROPS
(Taken from a list referring to a previous performance
at Brandeis, January 1968)[10]

2 16mm film projectors
1 35mm slide projector
1 tape recorder (speed 7 1/2)
1 opaque white projection screen 7'x9'
  (8'x6' at Anderson)
2 ordinary mattresses (no inner springs) 36" wide
2 12lb dumbbells
2 trapezes to be flown
2 3" thick slabs of soft polyurethane foam 4'x8'
  Bubble wrap and 1/2" black rubber [not listed
  in notebook]

## THE CHARACTERS
Seven ordinary people — three men and four women —
dressed in casual clothes typical of late 1960s Americans:
shirts, t-shirts, jeans / loose trousers and sneakers.
One 'magic-man' wearing a top hat.

## THE ACTING
Task- or work-like movement with a 'factual' quality,
in part presented with a smooth, apparently even,
energy continuum. Eyes averted from engagement with
the audience to create the effect of a blank gaze into
the mid-ground.

Note: The seven main characters remain onstage at all
times: while some perform, others watch.

## SCENE 1: *Trio A*
Three men stand still with heads positioned so as to
look to their left-hand sides before each begins to gently
swing his arms from the shoulder sockets in a control-
led but natural movement that circles back and forth
around the body as though they were rocks on pieces of
string. This marks the beginning of an approximately
four-and-a-half minute movement sequence, which all
three perform simultaneously, but not in unison.

## SCENE 2: *Trio B*
Three women perform a variation on the movement
sequence from Scene 1 in running steps, in unison.
At stage left, running up and down stage, are two 3'
wide strips of bubble-wrap and 1/2" black rubber
that make different sounds underfoot.

SCENE 3: *Mat*, then *Stairs*
A man and a woman manipulate two 4'×8' foam-rubber
gym mats and two 12lb dumbbells. As this part ends,
two men and one woman begin to climb up and down
a set of moveable steps, sometimes jumping off at the
top. They do this repeatedly, in different configurations,
with and without each other.

SCENE 4: *Act*
The whole group performs different actions using two
trapeze swings and one foam-rubber mat according to
rules that are hard to ascertain, while a magic-man in
a black dress suit and top hat appears temporarily and
performs juggling and magic tricks on the other side
of the stage.

INTERMISSION

SCENE 5: *Trio A1*
The three men from Scene 1 walk back and forth on
a diagonal line between two mattresses and take turns
lifting one another up in the air.

SCENE 6: *Horses*
To the recorded sound of a group of horses galloping,
the whole group converges at a specified point just
left of the centre stage before running together in
one direction, then another, then another, switching
apparently at random. A photograph of a herd
of Thompson's Gazelles running in the African
savannah is projected and a neon tube hangs above
the performers.

SCENE 7: *Film*
A film of feet gently kicking a ball is projected
onto a hanging screen and the group moves around
the stage creating floor patterns on different circular,
straight or diagonal trajectories, sometimes stopping
in specific poses; one pose is particularly familiar,
through association with a famous photograph
of Nijinsky.

SCENE 8: *Lecture*
A single woman repeats the movement sequence that
was performed by the three men in Scene 1, but she
is wearing tap shoes and the sound of her dancing
is accompanied by the regular clatter of wooden slats
being dropped one by one onto the floor from above.
A large wooden lattice descends in the middle of this
solo, filling the stage backdrop for one minute, then
ascends out of sight.

*Note: Before and between these various actions, interludes
occur — a taped conversation between a man and a woman
and pieces of music are played and a pornographic poem
is read aloud. The lights are turned on in the auditorium
between the acts.*

*The Mind is a Muscle*, then, presented a succession
of individual and group tableaux showing people
performing simple movements, negotiating or
manipulating objects, interacting with each other in
primary, physical ways and dancing *Trio A*. The way
that Rainer and some of her Judson peers directed
movement proposed that choreography might be a

kind of readymade aesthetic to be 'found' in city streets.[11] Rainer's choreography of primary gestures and interrelations transposed elements of New York City's complex network of pedestrian activity into the theatre frame and so dramatised the question of individual agency and society — on a personal level by positing mind as muscle, and publicly by investigating relations between the self and the group or crowd. In its mute physicality, *The Mind is a Muscle* staged a shift away from the notion that meaning comes about through individual expression of interiority and instead proposed a form of meaning that could be generated collectively and was readable at surface level.

My investigation of *The Mind is a Muscle* is an attempt to consider how and why Rainer presented 'work-like' performance as a shared language between a number of individuals who formed a particular kind of community, and what this presentation meant. I will consider the piece as a live manifesto that operated through two broad levels: firstly, by setting out Rainer's clearest presentation of her 'work-like' dance aesthetic, and within this, secondly, by framing the presentation of her discrete dance piece, *Trio A*. Looking at what was artistically and politically significant about such an attempt to find a different way to think, act, feel and dance, I will also consider how the significance of the ephemeral aesthetic that was *The Mind is a Muscle* persists.

## 2. Anybody and Everybody

### Minimalism

In its composite structure, *The Mind is a Muscle* naturally resembled not only the format of some of Rainer's previous evening-length works, but also the experimental mixed-bill concerts that had been presented at the dance theatre of the Judson Church in New York's Greenwich Village throughout the early-to-mid 1960s. These concerts provided the group of dancers with a display format for new work that operated on an indiscriminate basis. Alongside such fellow dance-makers as Steve Paxton, Deborah Hay, Trisha Brown, David Gordon and Lucinda Childs, Rainer had played a leading role at Judson, first taking part in, and then leading, dance workshops in the space. Like the others, Rainer had co-organised and contributed to 'Concerts of Dance', the first of which took place in July 1962,[12] in which she presented an important solo titled *Ordinary Dance*, which was a first step in presenting her 'pedestrian' movement aesthetic.

The ethos of the Judson Dance Theater evolved under unique conditions that owed a great deal to certain practical facts; an essential one was the offer of space in which to work and publicly perform from Howard Moody, the Judson Memorial Church's radically liberal minister. Moody also ran a gallery on Thompson Street that showed work by artists including Robert Whitman, Claes Oldenburg and Allan Kaprow, and organised discussions or protests 'around issues of civil rights, free speech, abortion rights and the decriminalisation

of prostitution', as Rainer recalls.[13] Since the Judson was, then, a place where the spirit of social engagement was very much in the air, the context itself might be said to have created certain conditions under which the pared-down, co-operative look of Rainer's choreography would be perceived as having manifest political implications. Indeed, claims for the work's 'democratic' nature in the writing of Sally Banes or Deborah Jowitt are often weighted toward its position within the unique free 'spirit' of its historical Village scene.

The most important thing that the Judson space provided, as Rainer described it, was 'an alternative to the once-a-year, hire-a-hall mode of operating that had plagued the modern dancer before.'[14] This had combined artistic and practical effect. On the one hand, the conflation of workshop and presentation space into one site no doubt contributed to the 'process' look of the choreography. On the other hand, when it came to presenting the work, there was no transition to an elevated 'stage' space: the public presentation of work did not sever the dancers' activities from their everyday working process, which literally took place on the same floor plane. Moreover, as Rainer noted, 'the pillars at Judson Church designated at that time a natural performing area';[15] this was not a frontal view, but rather demarcated a central space that could be viewed from at least three sides. The audience was thus seated, without chairs, on the same floor plane as the dancers, creating a view of the dance that was more sculptural than pictorial. This was, as Rainer herself noted, akin to the placement of contemporaneous Minimalist

sculpture directly on the floor without a pedestal to lift it into an 'aesthetic' sphere. Key performances that were presented at the Judson Dance Theater included Rainer's *We Shall Run* (1963), in which 12 people — dancers and non-dancers — ran in 'leaderless patterns';[16] *Index* by Judith Dunn (1963); *Proxy* by Steve Paxton (1961); David Gordon's *Mannequin Dance* (1962); *Lightfall* by Trisha Brown (1963); Steve Paxton and Yvonne Rainer's *Words Words* (1963); Lucinda Childs's *Geranium* (1965); Carolee Schneemann's *Meat Joy* (1964); and Robert Morris's *Waterman Switch* (1965) among many others.

Participation in the Judson Dance Theater by visual artists — most significantly Robert Rauschenberg, Carolee Schneemann and Robert Morris[17] in works such as *Pelican* (1963), *Meat Joy* and *Waterman Switch* (respectively) — undeniably amplified awareness of the dance work being produced within both the art world and the city at large. Such a blurring of artistic boundaries was characteristic of the wider context of art practice in New York at this time: Allan Kaprow and Claes Oldenburg's 'happenings' and George Maciunus's Fluxus activities had been taking place from the late 1950s to the mid-1960s and both championed 'ordinary' participation and everyday activity in different ways. Yoko Ono staged performance happenings in her loft, including a 1961 work by Judson dancer Simone Forti titled *An Evening of Dance Constructions*, which influenced Rainer. The Living Theater was also in full swing,[18] and it was the experience of seeing a 'female, funny, robust and stylish'[19] performance by Aileen Passloff that fuelled Rainer's desire to perform on stage.

While 1968 fell within the period documented by Lucy Lippard in her book *Six Years: The Dematerialization of the Art Object from 1966 to 1972* (1973), it is curious and troubling to note that, although the entries for 1968 include the 'dematerialised' practices of Carl Andre, Daniel Buren, Robert Morris, Hans Haacke, Sol LeWitt and Douglas Huebler (most of whom made work that was exhibited in a fixed material form of some sort), Rainer's work receives no mention. This omission makes little sense from a contemporary perspective, especially given Lippard's observation in an article she co-wrote with John Chandler about 'The Dematerialization of Art' for *Art International* (February 1968), that speaks of the possibility of the art object becoming obsolete in terms that could easily be drawn straight from Rainer's practice — identifying the double root of art's dematerialisation as a combined focus on 'art as idea and art as action. In the first case, matter is denied, as sensation has been converted into concept; in the second case, matter has been transformed into energy and time-motion.'[20]

Regardless of her associations with Minimalism, Rainer's attentions to the problem of negotiating her subjectivity in the world, to the *situation* of performance rather than just the spectacle, her involvement with non-dancers as well as those who were professionally trained and her manipulation of the conventions of a particular cultural form combined to frame her activities within the broader context of Conceptual art practice. It is within that broad artistic 'game' or dialogue that she took, as a

basic structure, the specific rules and format of the more tightly defined game called 'dance'. She was, after all, of the generation that Kaprow addressed when he said, 'Young artists of today need no longer say, "I am a painter" or "a poet" or "a dancer" [...] All of life will be open to them.'[21] As she wrote in the statement for *The Mind is a Muscle*, '"dancing" in a strict sense, is but one of the several factors in the work'.[22]

At the time of its making, the potential reception of Rainer's work as idea-based and non-material was perhaps complicated by its alignment with Minimalism in the visual arts; an artistic tendency which foregrounded the concrete experience of encountering artwork as a specific material object. Rainer herself made the connection explicit in an essay she wrote about *The Mind is a Muscle*, titled 'A Quasi Survey of Some "Minimalist" Tendencies in the Quantitatively Minimal Dance Activity Midst the Plethora, or an Analysis of *Trio A*'. The essay was included alongside writing on all the key Minimalist artists in Gregory Battcock's 1968 anthology.[23] Explicit also were her artistic collaborations, and her personal relationship, with Robert Morris. Not only were Minimalist-style props such as blocks, steps, slats or beams of wood used in the dances, she herself related her dances to object-sculptures, comparing the 'energy equality' and '"found" movement' in her work to their 'factory fabrication'; her 'task or task-like activity' to their 'literalness' (fig.13). She went so far as to conceive of the 'body as object'. These descriptions were typical of her writings about her dances, which she described in terms of

'work'; they were, she said, 'uninflected', 'ordinary' and 'pedestrian'. Moreover, she described the groupings of dancers moving left to right across the stage as a 'column'.[24]

Reflecting on the shape and material properties of columns was also a concern in a number of Robert Morris's works. One of his well-known early pieces, a performance titled *Column* (1961), was in fact conceived directly through his involvement in dance theatre alongside Rainer. As she notes in her auto-biography, *Feelings Are Facts: A Life* (2006), 'The column had originally been constructed and painted yellow by George Sugarman as *décor* for one of my early solos, *The Bells*, which I had performed on that same stage the previous year. Bob found it in the wings and painted it gray.'[25] In *Column*, Morris presented the newly grey plywood box, built to human scale, centre-stage when the theatre curtains opened. The box stood upright for three-and-a-half minutes, then, manipulated by a wire, fell over and lay prone for a further three-and-a-half minutes before the curtain closed. In the work of both Morris and Rainer, presentations of the body-as-object or object-as-body tested a continuum between inertia and movement or between the individual and the industrial, often with laconic, deadpan humour.

The alignment of Rainer's dance with Minimalist art can also be understood in terms of their mutual, contemporaneous association with a democratic spirit of stripped-down, materialist aesthetics. Sally Banes, author of *Democracy's Body: Judson Dance Theater*

*1962—1964* (1983), wrote that the new dance language formulated at Judson represented an 'assertion of the primacy of the body, of the body as the vital *locus* of experience, thought, memory, understanding and a sense of wonder'.[26] In the democratic spirit of the work there was, she said, 'a joyous defiance of rules — both choreographic and social; a refusal to capitulate to the requirements of "communication" and "meaning"'.[27] The same principle of 'democracy' that was attributed to Judson dance by Banes and others was invoked in the then-current discussions of Minimalist sculpture. In this vein, curator Kynaston McShine claimed, in the catalogue for the 1966 Minimalist sculpture exhibition 'Primary Structures' at the Jewish Museum in New York, that the use of 'a standard fabricated unit by Donald Judd, Carl Andre and Dan Flavin gives their work [...] an availability and accessibility which removes sculpture from any connotation of the precious "fine arts" object'.[28] Although Rainer's work has been seen primarily in relation to Minimalism, indeed as a parallel equivalent in her own chart, it is important to consider the way in which her overall approach exceeded its concerns conceptually. Instead, Rainer's work might be seen to mark out new territory that bridged a gap between the object-centred paradigm of Minimalism and the expanded practices aligned with Conceptualism or Fluxus.

The concerns of Minimalism, Conceptualism and Fluxus were played out against the political movements of the historical moment. Consequently, it is against a backdrop of civil-rights protest culture, as well as

avant-garde participation in dance and theatre, that Rainer's own particular take on what democracy meant in art terms must be considered. The question of democracy is commonly figured in her work at two levels: one, in terms of a fairly literal notion of how the work has involved group participation, creating tableaux of egalitarian relations between bodies performing tasks that defy any form of hierarchal organisation; and another at which the art object is posited as a contingent point of negotiation, rather than a transcendent or fixed entity. However, while the early Judson concerts contained mixed programmes of work contributed in an egalitarian manner by any participant proposing a piece they had rehearsed,[29] *The Mind is a Muscle*, like her earlier evening-length work *Terrain* (1963), was authored solely by Rainer.[30] While forms of chance improvisation had played a key part in the genesis of this new kind of choreography, as a result of Robert Dunn's John Cage-informed workshops,[31] held in Merce Cunningham's studio between 1961 and 62,[32] it is important to acknowledge that as she developed her own practice, Rainer would transpose the notion of improvisational decision-making into its formal *representation*, therefore *representing* a particular version of democratic participation within parameters strictly set by the choreographer. As she later recollected, noting the artifice underlying this approach, '[my work] had a kind of provisional *look* to it, as though it doesn't *have* to be this way, it might be another way. A lot of Judson work had that look to it.'[33] That Rainer emphasises the appearance rather than the genesis of the work is of key importance to her attitude to authorship.

Though she had been very much influenced by the chance compositional methods of John Cage, she said of her ultimate quarrel with his approach:

*We can't have it both ways: no desire and no God. To have no desire — for 'improvements on creation' — is necessarily coequal to having no quarrel with — God-given — manifestations of reality. Any such dispassionate stance in turn obviates the necessity of 're-telling' the way things have been given.*[34]

Rainer's own philosophy of authorship incorporates elements of chance and participation, but clearly privileges her own desire, rejecting what she saw as the passive transposition of 'God-given' reality into the aesthetic frame.[35] Rainer selected found movement as her material — whether from everyday pedestrian or work activity, ballet, contemporary or popular dance, mime or vaudeville — and choreographed specific patterns and combinations from this material so as to 're-tell' an image of social relations via particular images, atmospheres and effects. An image of 'democratic cooperation' was one of these effects, but it is important to note that at this point in her career, this was deliberately not the creative principle of the work's genesis.[36]

If the true essence of democracy is understood, as Jacques Rancière has defined it, as a simple agreement about 'the ability of anybody and everybody to govern',[37] then its relevance to the early years of the participatory workshop context and free attitude to presentation at

Judson (1962–66), in which 'there was no one person's work that was highlighted or dominated', is apparent.[38] But in her later work, which culminated in *The Mind is a Muscle*, Rainer was deliberately shaping or 're-telling' the everyday by creating certain kinds of images from gestural patterns — and, in choreographing *Trio A*, making an equivalent 'fine art' object. The idea of 'democracy' in relation to Rainer's work at this point — as indeed to the moveable elements within Robert Morris's contemporaneous permutations, series or anti-form sculptures — was a strategy for the organisation of elements within a work of art.[39] Yet, at the same time, it was precisely through her staged theatre of relations and operations — through her authorial ability *to tell a story*, so to speak — that Rainer created model forms of social relations that re-imagined prevailing social scripts determining how people might act, cooperate, be, alone and together.

## The Image

If we understand Rainer's creation of her pedestrian movement aesthetic not as workshop but as theatre with a 'process' look, and her directing of found movement not as simple displacement but as a way of 're-telling', her conflicted relationship to the dominant realm of representation — what Guy Debord characterised as 'the image' — comes into focus. In 1965, Rainer wrote her 'NO manifesto':

*NO to spectacle no to virtuosity no to transformations and magic and make-believe no to the glamour and transcendency of the star image no to the heroic no to*

*the anti-heroic no to trash imagery no to involvement of
performer or spectator no to style no to camp no to seduction
of spectator by the wiles of the performer no to eccentricity
no to moving or being moved.*[40]

Rainer's use of the term 'spectacle' prefigures the title
and theme of Guy Debord's publication, *The Society of
the Spectacle* (1967). Debord positioned the 'image' as
a realm wholly detached from, but dictating to, lived
life, defining the spectacle as 'a social relationship
between people that is mediated by images'.[41] In
Debord's formulation, the abstracted image proposes
and alienates the subject's needs to such an extent that
'the individual's gestures are no longer his own, but
those of someone else who represents them to him'.[42]

Considering the role of the image defined in this way,
and Rainer's relationship to it as such, brings to light
a third interpretation of how her work engaged with
questions of democracy and participation: one that
pertains to contemporary media culture in America
at the time, especially the place of television. Elements
of Rainer's work, not least her desire to maintain
the authority of authorship, indicate her awareness
that participation and democracy were already, at
that moment, becoming suspiciously co-opted concepts.
'Democracy' in 1960s America may have felt like the
anarchic, rule-breaking joyousness that Sally Banes
describes, but in retrospect, it was underwritten by
a new material affluence that gave birth to an idea
of open-to-all 'participation' that has been negatively
reinterpreted by political and economic theorists since

the 1980s. Gilles Lipovetsky, for example, saw these conditions as having bred an extreme and atomised individualism focused on the here-and-now, one that subsequently allowed for the total penetration of the social fabric by free-market capitalism.[43] Rainer's take on democracy was, I propose, not simply a utopian proposition about equality, but very much permeated by her awareness of her own position within the strengthening free market of post-War America. Rainer's relationship to America's growing media-image culture had been a conscious and conflicted one, from her early diary entries complaining of feelings of embarrassment and 'discomfort' at her consumer freedom in 'choosing things' related to 'the adornments of the modern female',[44] through to the beginning of her dance career, when she and Trisha Brown performed *Two Satie Spoons* (1962) and incorporated within their ordinary dance language pin-up girl 'cheesecake' poses found in magazines. Rather than proposing an outright rejection, however, Rainer grappled with image culture's inevitable presence, making space to inhabit it on her own terms.

While Rainer was preparing and developing *The Mind is a Muscle* in 1967, her brother Ivan wrote to her to tell her that he had finally succumbed to buying their mother a TV. Rainer herself had bought one two years earlier, and it is her traumatised perception of the split psyche that television news images create which led her to assert her 'horror and disbelief upon seeing a Vietnamese shot dead on TV' in *The Mind is a Muscle*'s programme sheet. 'Not at the sight of death,' she

continues, 'but at the fact that the TV can be shut off afterwards as after a bad Western.' In the final paragraph, Rainer claims that ideological issues 'have no bearing on the nature of the work' and ends the text with the assertion, 'My body remains the enduring reality'.[45] This assertion should not, I believe, be read as a denial of engagement with the media, but as one moment in the complex series of back-and-forth negotiations that make up her analytical relationship to it.

Rainer's work did not, then, propose an inalienable, utopian sphere for her art practice. Instead, she situated it firmly within a nascent American individualist or materialist notion of 'democracy' — the notion of democracy that was anticipated by Andy Warhol's legendary attributions that every American would now be able to buy and drink the same can of Coca-Cola, and would be famous for 15 minutes.[46] If Rainer's work represented a new narrative script for relations between people, one that deliberately countered the sales-geared 'images of need proposed by the dominant system' of the spectacle,[47] it was also true that, in order to create that representation, she had to grapple with her entanglement with image culture. In the presentation of *The Mind is a Muscle* at the Anderson Theater, she was creating gestural tableaux on a proscenium stage that specifically created a picture view. Quite distinct from the floor-based single plane of the Judson, it was in image form that Rainer's retelling necessarily took place. Although her aesthetic refused *illusion* and stardom of a particular, theatrical kind, Rainer was always upfront about her fascination with being witnessed by

an audience and with feedback. 'I drool in my pants when I think of that huge attendance — exhibitionist that I am' she wrote of her appearance at the Washington, D.C. 'Now' festival in 1966.[48] Whatever the work represented as an experience for its participants, and however much her dancers exhibited an autonomous look, its primary purpose was to hold the audience's attention, to be seen.

Rainer's engagement with mainstream culture, however, was apparent not simply because her work utilised the image plane as the necessary interface between the seated audience and those on stage. Evidence shows that she specifically wanted to draw attention to her own work as 'entertainment'. A letter to the organiser of the first run of the evening-length piece at Brandeis earlier in 1968 details, extraordinarily, her request to have men 'patrol the aisles' selling candies and ice creams, and to have refreshments provided for the interval breaks. Rainer wrote in a letter to Benjamin Buchloh on 10 November 1974 that she considered herself to have been 'a maker of shows in the broadest sense'.[49] Her inclusion of the top-hatted Harry De Dio performing magic tricks in *Act* further emphasises this. Where John Cage refused to perform in works such as *4'33"* (1951), where the performer sat silent for the stated duration, Rainer performed — entertained even. She created artworks — dances — that, she explicitly acknowledged, she wanted people to want to see. Although boredom and failure were intrinsic qualities within the work, she explicitly invited the frame of cultural entertainment in. Rainer's

work took from the dominant culture what was useful, the 'hooks' of capitalist image-making, and it was within that frame that she created different kinds of images, resisting clichés and ideological scripts that stereotyped gender, labour, beauty, high or low art.

Rainer's choice to present work in a theatre was nevertheless also distinct from television entertainment. The physical structure of stage and audience seating served to bridge the widening gap between private consumption of the media and an awareness of shared publicness. In the same letter to Buchloh, she wrote of her choices of medium, dance or cinema: 'I have always made a public art to be viewed by people sitting together in a public space.'[50] Onstage, Rainer's work revealed and celebrated the heaviness of real women's and men's bodies that (distinct from the *pointe*-shoed sylphs of traditional ballet) acknowledged gravity: her performers walked up and down steps in repeated patterns, and struggled to lift each other, or a bulky mattress, with movements that were strong and clear. The grace of recognisable effort as a number of people danced *Trio A* together but at their own pace rather than in unison, served as a matrix to foreground not sameness but individuality. In the early version of *Lecture*, at the end of the piece, Rainer tested the phrase-less continuum of her own body dancing *Trio A* and the sound of her tap-shoed feet on the floor against the loud and primary 'metronome' effect of regularly falling wooden slats. With her incorporation of 'found' movement woven together with dance, the *dispositif* of the theatre structure itself inserted temporary

parentheses around an aesthetic that would otherwise be mobile and dispersed. And yet this potential for dispersal — that the dance may be carried with the dancer into the street — was an essential part of the work, and something that she used to political effect in pieces staged in New York, such as her group pedestrian protest *Street Action* in 1970 which incorporated the movement 'M-Walk' taken from the march of the alienated workers in Fritz Lang's *Metropolis* (1927).[51]

To grasp the implications of Yvonne Rainer's formulation of a dance language built from straightforward physical actions and developed through patterns of 'interaction and cooperation' between people engaged in 'task-like' activities,[52] it is useful to consider the way in which Rancière describes relations between the social and the aesthetic fields. In *The Politics of Aesthetics* (2004), he analyses the relationship between art and life by considering the ensemble of human relations and activities as a dynamic field, which depends upon prescribed inclusions and exclusions that might — and in a democracy, should — be challenged. It is on the level of the patterns that underlie our everyday life, he argues, that social power structures manifest themselves. Hierarchies are enforced not only through the manner in which people deal with each other and assign social positions, but also through the attitudes that determine how people experience life under the conditions created by a given society. So for Rancière, the social field is organised through structures that govern the 'distribution of the sensible', that being 'the system of self-evident facts of sense

perception that simultaneously disclose the existence of something in common and the delimitations that define the respective parts and positions within it'.[53]

Rancière depicts ideology quite clearly in embodied form, describing emancipation and dominance in terms of relations evidenced in bodily positions, gestures and forms of experience. Against this backdrop, he defines artistic practices as 'ways of doing and making' that intervene in the general distribution of 'doing and making', and can therefore create the potential for change in modes of experience.[54] While the activity of creating an art object always involves 'doing' and 'making' in ways that to some degree disrupt a conventional understanding of labour in economic terms, 'doing' and 'making' occur in Rainer's work in the most literal, and the most vital, sense. In her choreography, the 'making' of the work is simultaneous with and dependent upon its 'doing' as performance; it *is* process and action. Tautologically, the work (of art) is simultaneous with the work (effort) of its execution. It is precisely by virtue of its performance creating images of a radical literalness that *The Mind is a Muscle* presents itself as an intervention into the dominant patterns of action, consumption and experience and can be seen as an attempt to address the structures that govern the given 'distribution of the sensible' in society at large.

In a complexly contradictory way, Rainer's dance switched back and forth between images of cooperation between men and women alike that prioritised the texture of relationships as the substance of the work

over and above outcomes or objects, as well as presentations of the body-as-object, either as a heavy weight to be lifted or as mannequin-style automaton. In these moments — when the dancers performed 'M-Walk', or ran together as a 'pack' in *Horses*, taking cues to continuously switch directions, or maintained the blank and mask-like expression referred to as the 'Judson stoneface', which made them look at times like curious mannequins in a shop window — Rainer appears deliberately to invoke self-critique. Her aesthetic was grounded in images of equality and participation, but she was directing the dancers as her 'workers' nevertheless. She has said, in retrospect, that in teaching her dancers what to do, she was 'a pretty tyrannical director'.[55]

Such contradiction erupts continuously in Rainer's work and, in so doing, disrupts the kinds of familiar, abbreviated patterns of characterisation utilised by the narratives of mainstream entertainment. Norman M. Klein has analysed 'audience culture' in relation to television, of which he says the constant interruptions of commercial breaks force it into a fragmentary pattern that requires only a superficial level of engagement:

*Gestures, images, lighting effects repeat so often on television they apparently are received more as a rhythm than a coherent statement. Flashes of information must be highly abbreviated, so familiar to the viewer that only an outline or a phrase is needed.*[56]

It was against such a backdrop that Rainer's presentation of people performing tasks in unhurried real time inserted itself into the nascent spectacle culture in order to challenge these abbreviated rhythms, creating images of 'doing' and 'making' from palpably living bodies in an intimate theatre space, witnessed by a live community. And yet her work does not fit straightforwardly into an idea of alternative culture as pure 'resistance'.

Rainer's relationship to popular culture was complicated further by the fact that, despite its firm roots in a political and artistic counter-culture, both the Judson Dance Theater and Rainer's work in subsequent years were surprisingly well-embedded in the cultural sphere covered and celebrated by the New York media. At one level, the Judson relied upon a community of interest with its own specific kind of visibility, largely created by and for a closely-knit 'scene'. But it was also true that the emerging scene was propelled and, in a sense, bound together by the newspaper reviews of Jill Johnston from the *Village Voice*, whose weekly write-ups championed, analysed and, importantly, advertised the work. Reviews of the concerts of dance also appeared quite regularly in *The New York Times* as well as the *New York Herald Tribune*, *The Washington Post*, and of course dance and art publications such as *Dance Magazine*. Although Rainer has spoken of the 'scene' as though it was a very inward-looking underground movement,[57] she was in fact quite frequently written about or quoted in the arts press, even being featured in 1967 as one of '100 American Women of Accomplishment' in *Harper's*

*Bazaar* magazine. Before it was presented as a complete work, *The Mind is a Muscle, Part 1 (Trio A)* had already been reviewed several times: after its first presentation at Judson in 1966 in New York; when danced as *Convalescent Dance* in Washington, D.C. in 1967 by a shakily weak Rainer, who had just come out of hospital;[58] and within the first version of the full *The Mind is a Muscle* programme at Brandeis in early 1968. In this sense also, Rainer's relationship to the 'star image' was more complex than her stated rejection admits. She gained, and has maintained, a certain star status and recognition of her own within this scene. It would be truer to say that Rainer redefined the capacities of the dance star than to say that she rejected them completely.[59] In this sense also, as a woman who did not pander to stereotypical femininity, she challenged Debord's identification of how 'the cinema [as a facet of the Spectacle] presents heroes and exemplary conduct modelled on the same old patterns'.[60]

## 3. Scripts

### Inside Out
In the three-paragraph typewritten statement that accompanied *The Mind is a Muscle*, Yvonne Rainer wrote of her 'ongoing argument with, love of and contempt for dancing', of its inherent 'narcissism', but also of her straightforward love for 'the body — its actual weight, mass and unenhanced physicality'. Emphasising text and dance as parallel modes of communication, rather than either illustrating the other, the statement

was prefaced by a bracketed disclaimer informing the audience that 'It is not necessary to read this prior to observation.' In conceptual terms, though, it was an essential part of the piece. As is evident in the body of texts made in parallel to her choreography, writing was as much a love of Rainer's as dancing. Perhaps her first love, even. Box 1 of her personal archive, now held at the Getty Research Institute in Los Angeles, yields a number of private journals, including two that were written when Rainer was between the ages of 16 and 18.[61] Streams of words in wavering blue-ink pen fill every inch of space on the pages of these lined notebooks, intricately detailing Rainer's thoughts, experiences and confessions.

What is intriguing about these early writings in relation to Rainer's later project lies not only in the way in which she has used extracts from them in her work — as an anonymous accompaniment to her film *Journeys from Berlin* (1971), and in her memoir *Feelings Are Facts: A Life* — but also in the way that the narrative thrust of the chronological entries is so often interrupted by the writer's reflection on the fact of her drive to document her experience, and on her awareness of this drive even when her 'mind is a void' and she has 'nothing to say'. It is a 'compulsion', she says. Tellingly, the teenage Rainer anticipates the diary's future reader — who may, she acknowledges, be her future self, then berates herself for such 'false' desire and 'pride'. In her entry on Saturday 5 May 1949, she writes that as a child:

[...] *whenever I was alone I would 'perform'. I don't think I did anything unusual or dramatic at these times, but the things I did do* [were] *with the thought in mind that I was being watched. Now this reaction is becoming more and more unconscious, having been transmitted to my actions, speech, writings and my thoughts.*

Already at this stage, Rainer perceives both doing and writing as kinds of 'performance' for an imagined audience, 'as though I were turned inside out and the outside were looking in'.[62] Rainer writes to analyse or project her sense of self with an acute awareness of publicness. Her journals betray a voice somewhere between the to-the-minute accounts of the heroine Clarissa in the eponymous eighteenth-century epistolary novel and the postmodern subject Baudrillard wrote about, for whom 'the virtual camera is in one's head.'[63]

Considered alongside the numerous letters, journals and diaries in her archive, Rainer's published history testifies to the continued significance of the written word as a part of her practice. She says, in the introduction to her 1974 book *Work 1961–73*, that it is her 'not easily assailed conviction that [language] above all else offers a key to clarity'.[64] Like many artists of the time (Donald Judd, Robert Morris and Carl Andre, to name but a few), she used parallel textual statements and complex titles alongside the work that she made. In Rainer's work, the capacity of the 'object' — ie., the body — to speak dramatised the relationship between word and image more intensely. In an early solo, *The Bells* (1961),

she said out loud, 'I told you everything would be alright, Harry', radically breaking with the convention of the silent dancer-as-body. In *Ordinary Dance* (1962),[65] Rainer read an autobiographical text (also taken from diary extracts) aloud while performing a choreographic sequence, endowing her body with a voice that pointed to her own agency and history — not as a body directed by someone else to perform, but as a thinking, doing body with a past as well as a present. The mind/body question as it is framed in Rainer's work through the 1960s finds its central axis in formation here: words both leap ahead of and drag back against the immediacy of live physical presence, situating the performer in a broader social and autobiographical context than the parenthetic frame of 'dance' theatre would ordinarily permit.[66]

It is significant to note that, while in her dance classes with Merce Cunningham, Rainer would no doubt have trained in a dance studio lined with large mirrors, the Judson Church, where her own work was generated, was not equipped in this way. Rainer recalls, though, that she had asked her then-partner, the painter Al Held, to make a large mirror for her to use in her own private apartment space.[67] The dance studio's mirrored wall is of course intended to make the dancer aware of the appearance of his or her technique, but was no doubt also a factor in Rainer's perception of dance's problematic 'narcissism' and 'preening'. Rather than focusing straightforwardly on the external perception of one's image in dance — verified in private practice by the mirror and on the public stage by audience

appreciation — Rainer exhibited an interest in multiple channels of feedback and reflection that could lend the dancer self-recognition, including the 'mirror to experience' provided by language.[68] This approach positioned her in a situation that expanded upon the conventional short circuit of audience relations via links to real-life experience. In the Anderson Theater it was the back of the *stage* that was equipped with a huge mirrored piece of Mylar, crudely indicating the performer-audience's two-way reflectiveness (fig.11).

## Games

The unexpected eruption of a voice from the typically mute body of the dancer in *Ordinary Dance* might be said to have dramatised a dual approach to the question of words and gestures as parallel but unconnected activities emanating from the same subject, and 'without any dramatic or rhythmic relationship existing between [them]'.[69] Rainer has described this approach as 'paratactic':[70] abstracting the generalised idea of 'performance' as speaking and acting a role by splitting it down the middle and presenting the self acting out that split, so as to emphasise the artificiality or performativity of both aspects. In its complete manifestation as a work for seven dancers some six years later, *The Mind is a Muscle* proposed a version of performance that expanded this split into a group situation via multiple, interlocutory dynamics of reciprocal movement interaction and audience response. In all of Rainer's dance work, and later in her films, words and gestures are presented or treated as two kinds of communication that only make sense in use, two

kinds of surface interface whose existence relies upon a relationship with other people, and through which one can be perceived. As the performative quality of her early diaries reveals, Rainer understood language, as Wittgenstein formulated it, as social exchange formulated between users by participation in the 'language games' that demonstrate its meaning.[71] Tellingly, in regard to Rainer's task-like aesthetic, Wittgenstein's narrative demonstration of the simplest form of a 'language game' is described in terms of simple words and objects exchanged between a builder and his mate, who are labelled A and B:

*A is building with building stones: there are blocks, pillars, slabs and beams. B has to pass the stones, in the order in which A needs them. For this purpose they use a language consisting of the words 'block', 'pillar', 'slab', 'beam'. A calls them out — B brings the stone which he has learned to bring at such and such a call. Conceive this as a primitive language.*[72]

The lucid, athletic form of Rainer's choreography in *Stairs*, *Mat* or *Act* from *The Mind is a Muscle* was built from a similar reduction of movement language to its elemental principles. Although her scores often indicate a system of relations between instruction and action that are similar to those that Wittgenstein's 'A—B' dialogue relies on, the performances in *The Mind is a Muscle* do not reveal these underlying rules; they present a physical manifestation of a language of interaction being played within a community of dancers, as though naturally understood. In this sense, the work's lexicon

is presented as though it might be a blueprint for a new 'culture' in the making. The dancers, in these works, perform images that imagine the simplest elements of dance language. There is some proximity between Rainer's approach and the spirit of a certain radical pragmatism, found in Wittgenstein's philosophy, that seeks to find truth in basic language by deflating overblown forms of expression. But to what degree Rainer could actually be understood to have embraced belief in the body as a rock-bottom of reality remains in question. Rainer speaks about her body in a decidedly laconic and anti-metaphysical way as bare matter. Her pragmatist stance led to an aesthetic of radical laconicism that bypassed the fundamental question of bodily 'authenticity', and instead formulated new ways of behaving or performing her self.

Rainer has said that her choice of title for the work 'spoke about the life of the dancer — a life of work, dedication, of the mind requiring the same kind of daily work and stimulation as the dancer's muscle'.[73] But the concepts compressed in the title *The Mind is a Muscle* itself open a more complex two-way street in the relationship between doing and thinking. Mind-as-muscle signifies a conflation of action and consciousness, readable as gesture. Rainer had for some time been fascinated with the idea of inverting the conventional hierarchy of the head and body in dance, where the face was a locus of expression with dancers engaging with each other via exaggerated eye contact and stylised facial attitudes. In the process of working this idea through, before she had devised *Trio A* with

its averted gaze, she experimented with blotting out her features using black face paint so as to weight the body equally with the head.[74]

However, *The Mind is a Muscle* speaks at the same time of the potential for transference between idea and matter. Between 1966 and 1968, while Rainer was developing this work, she also spent considerable periods of time in hospital suffering from a severe intestinal illness. A letter she wrote to her brother Ivan at this time speaks of her physiological state in dryly corporeal terms: 'They say the mind is made of grey matter. I think mine has become brown matter.'[75] And yet, with the practical facility of her Wollensack tape recorder, she continued to make dance from her physically debilitated position. Rainer recalls that she made a tape of herself reading out loud her doctor's letters to her New York gastroenterologist.[76] She asked Becky Arnold and Bill David to perform *Mat* from the as-yet-incomplete programme for *The Mind is a Muscle* to the accompaniment of this reading as a part of a 'Choreoconcert' at New York's New School for Social Research in October 1967, noting that 'The absent choreographer was thus invoked in her diseased particulars while the robust dancers went through their athletic paces with two mats and two 12lb dumbbells.'[77] The mind is made muscle by proxy.

An understanding of shared language between the dancers of course existed in a real sense, in terms of their participation in the Judson/New York avant-garde scene, but the specific look of Rainer's choreography

and its 'interaction and cooperation' was directorially rather than cooperatively determined. What, then, was the relationship between what has been understood as a claim for authenticity at stake in Rainer's statement at this point that her body, distinct from the media image, was her 'enduring reality' and the communal, rehearsed nature of the theatre work's genesis, in which she directed others to move in certain ways? It is helpful to retrace some familiar art-historical steps to answer this question. 'The Legacy of Jackson Pollock', Allan Kaprow's famous 1958 essay on the origins of his 'happenings' — events that were of course highly influential on the Judson scene — posits Pollock's 'dance of dripping, slashing, squeezing, daubing', as his method of painting was captured on film by Hans Namuth, to be the turning point in late twentieth-century art history.[78] Kaprow identifies this action as the transition point from the flat, painted canvas of high modernism to the expanded 'arena in which to act', which might embrace all manner of everyday materials as a subject. There is an enthusiastic agility to Kaprow's perception of what the work, to his mind, opened up; 'to grasp a Pollock's impact properly, we must be acrobats', he wrote.[79]

The repetitive demands of performing the making of his painting specifically for the film left Pollock increasingly depressed. It is legendary that shortly after the filming, he angrily told Namuth, 'I'm not a phoney, you're a phoney.' Rosalind Krauss notes this episode in *The Optical Unconscious* (1993): 'His sense of fraudulence never left him after that [...]. The following year's

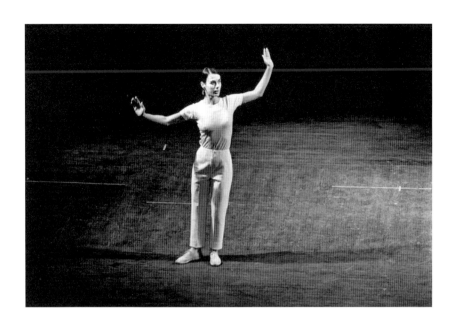

1. *Trio A (Convalescent Dance)*,
Hunter Playhouse, New York, 1967.
Yvonne Rainer solo.
Photograph by Peter Moore.

# THE MIND IS A MUSCLE
## by
## YVONNE RAINER

at the Anderson Theater April 11, 14, 15, 1968

with

| Becky Arnold | William Davis | Harry De Dio |
|---|---|---|
| Gay Delanghe | David Gordon | Barbara Lloyd |

Steve Paxton          Yvonne Rainer

The approximate running time of the evening is one hour 45 minutes.

interlude #1: Conversation (*Lucinda Childs, William Davis*)

1. Trio A ............William Davis, David Gordon, Steve Paxton
2. Trio B ...........Becky Arnold, Gay Delanghe, Barbara Lloyd

interlude #2: Dimitri Tiomkin (*Dial M for Murder*)

3. Mat then .......... Becky Arnold, William Davis
   Stairs ........David Gordon, Steve Paxton, Yvonne Rainer

interlude #3: Henry Mancini (*The Pink Panther*)

4. Act ............. Harry De Dio
                     Group

## INTERMISSION

interludes #4: The Greenbriar Boys (*Amelia Earhart's Last Flight*)
           #5: Silence (6 minutes)
           #6: Frank Sinatra (*Strangers in the Night*)
           #7: Conversation (continued)

5. Trio A¹ .......... William Davis, David Gordon, Steve Paxton
6. Horses ..........Group

interlude #8: John Giorno (*Pornographic Poem*)

7. Film ............. Group
                Foot Film by Bud Wirtschafter; Hand Film by William Davis
8. Lecture .......... Yvonne Rainer

interlude #9: Jefferson Airplane (*She Has Funny Cars*)

2. *The Mind is a Muscle* programme,
Anderson Theater, New York, 1968.

# STATEMENT

(It is not necessary to read this prior to observation.)

The choices in my work are predicated on my own peculiar resources — obsessions of imagination, you might say — and also on an ongoing argument with, love of, and contempt for dancing. If my rage at the impoverishment of ideas, narcissism, and disguised sexual exhibitionism of most dancing can be considered puritan moralizing, it is also true that I love the body — its actual weight, mass, and unenhanced physicality. It is my overall concern to reveal people as they are engaged in various kinds of activities — alone, with each other, with objects — and to weight the quality of the human body toward that of objects and away from the superstylization of the dancer. Interaction and cooperation on the one hand; substantiality and inertia on the other. Movement invention, i.e. "dancing" in a strict sense, is but one of the several factors in the work.

Although the formal concerns vary in each section of THE MIND IS A MUSCLE, a general statement can be made. I am often involved with changes as they are played against one or more constants: Details executed in a context of a continuum of energy (Trio A, Mat); phrases and combinations done in unison (Trio B); interactive and mutually dependent movements done in a singular floor pattern (Trio A$^1$); changing floor patterns and movement configurations carried out by a group moving as a single unit (Film, Horses); changes in a group configuration occurring around a constant central area of focus (Act); and more obvious juxtapositions that involve actual separations in space and time.

The condition for the making of my stuff lies in the continuation of my interest and energy. Just as ideological issues have no bearing on the nature of the work, neither does the tenor of current political and social conditions have any bearing on its execution The world disintegrates around me. My connection to the world-in-crisis remains tenuous and remote. I can foresee a time when this remoteness must necessarily end, though I cannot foresee exactly when or how the relationship will change, or what circumstances will incite me to a different kind of action. Perhaps nothing short of universal female military conscription will affect my function (The ipso facto physical fitness of dancers will make them the first victims.); or a call for a world-wide cessation of individual functions, to include the termination of genocide. This statement is not an apology. It is a reflection of a state of mind that reacts with horror and disbelief upon seeing a Vietnamese shot dead on TV — not at the sight of death, however, but at the fact that the TV can be shut off afterwards as after a bad Western. My body remains the enduring reality.

Yvonne Rainer
March, 1968

3. *The Mind is a Muscle* programme
statement, Anderson Theater,
New York, 1968.

## 2. Trio B

I.   Running
     Before 1. (below), run in

II.  1.  Walk, walk, run, run, walk combination, moving upst.,
       d.s. r. diag., str. across to left. It goes into
   2.  Skip, skip, bent-leg (r.) ronde-de-jambe combo. It
       goes into
   3.  Curve back against 1. croisé bent leg, then veers back
       as leg straightens, 1st position, l. leg lunges to
       side and torso drops over to r. bent knee, etc. ends
       in cartwheel.
   4.  Walk on heels upst. diag. l. ˙
   5.  Run - 5 steps diag., 3 steps front in V formation
   6.  "Sixes"
        a.  Ordinary
        b.  Step on left to s.r. Continue to turn r. and
           finish s.l.
        c.  Step on s.l., pivot backwards in same direc-
           tion.
        d.  Step to s.r., pivot forwards and continue
           to s.l.
        e.  Step to s.l. on left and right feet, then
           reverse direction on last step, then reverse
           direction to start a. again.
        f.  Step backwards to stage r., pivot forwards on
           left foot and finish to stage l.
   7.  3 kinds of skips going into 1,2,3,4, and 5, and 6 and

   8.  ↓ sideways skittering

      ↑ running backwards

      ↓ 2 steps in demi-plié, 2 in parallel ½ - toe

      ↑ sidewards skitter and sidewards leap

      ↓ hip-swivel run with scrunching of torso

4. Notes on *Trio B*, 1968.

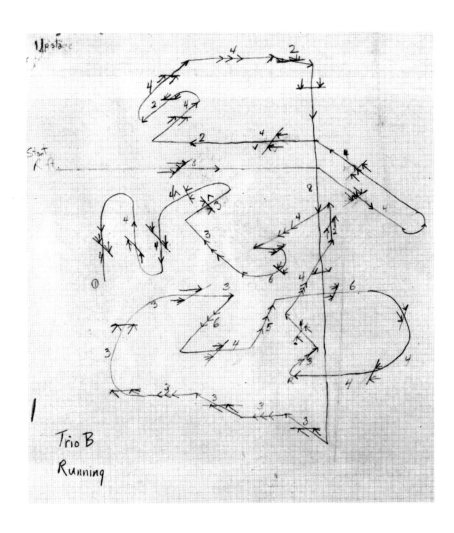

5. Detail of *Trio B* floorplan, 1968.

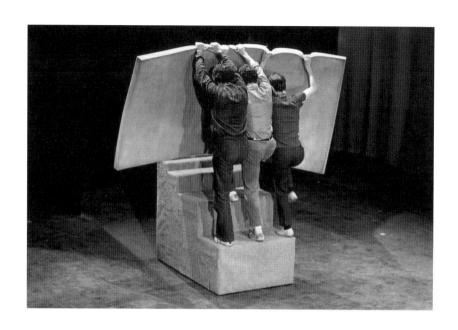

6. *Stairs*, Anderson Theater, New York,
1968. David Gordon, Steve Paxton
and Yvonne Rainer. Photograph by
Peter Moore.

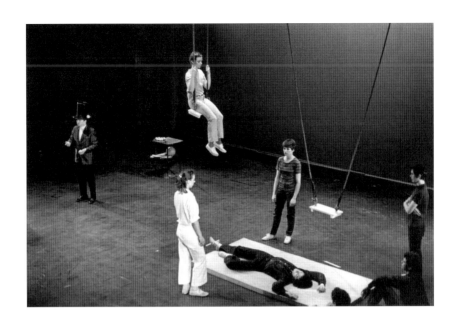

7. *Act*, Anderson Theater, New York,
1968. Harry De Dio, Barbara Dilley,
Gay Delanghe, Steve Paxton, Becky Arnold,
Bill Davis, David Gordon and Yvonne
Rainer. Photograph by Peter Moore.

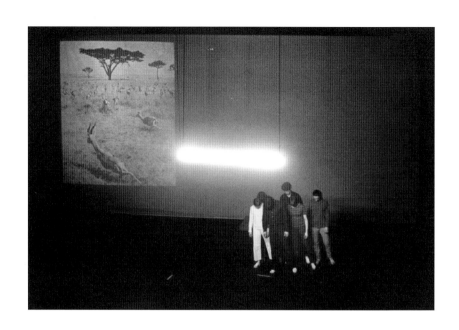

8. 'M-Walk', *Horses*, Anderson Theater,
New York, 1968. Photograph by
Peter Moore.

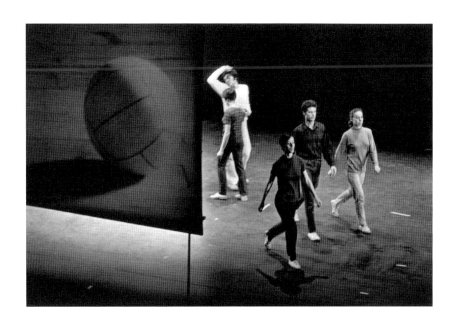

9. *Film*, Anderson Theater, New York,
1968. David Gordon in Nijinsky
pose, Gay Delanghe, Yvonne Rainer,
Bill Davis and Becky Arnold.
Photograph by Peter Moore.

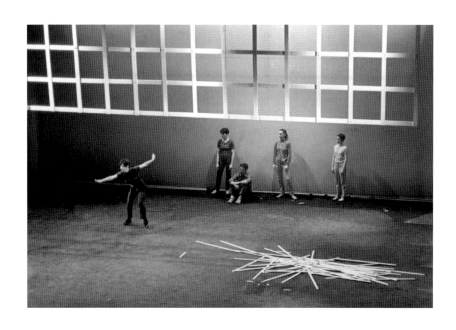

10. *Lecture*, Anderson Theater, New York,
1968. Yvonne Rainer. Photograph by
Peter Moore.

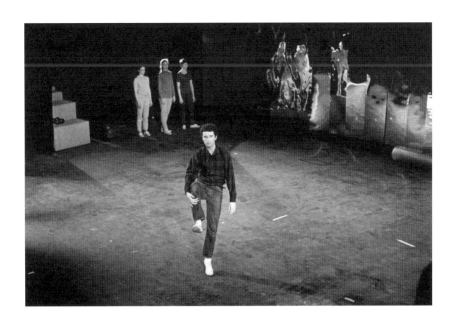

11. *Trio A*, Anderson Theater, New York,
1968. Bill Davis (with Steve Paxton
and David Gordon, not pictured).
Photograph by Peter Moore.

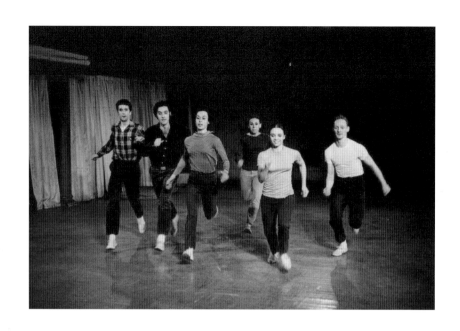

12. A transitional moment in *The Mind
is a Muscle*, Judson Church, New York,
1966. Bill Davis, David Gordon, Yvonne
Rainer, Becky Arnold, Barbara Dilley
and Peter Saul. Photograph by Peter Moore.

|                     OBJECTS                          |                     DANCES                          |
| --- | --- |
| eliminate or minimize |||
| 1. role of artist's hand | phrasing |
| 2. hierarchical relationship of parts | development and climax |
| 3. texture | variation: rhythm, shape, dynamics |
| 4. figure reference | character |
| 5. illusionism | performance |
| 6. complexity and detail | variety: phrasing and the spatial field |
| 7. monumentality | the virtuosic movement feat and the fully-extended body |

| substitute |||
| --- | --- |
| 1. factory fabrication | energy equality and "found" movement |
| 2. unitary forms, modules | equality of parts |
| 3. uninterrupted surface | ( discrete events or repetition ) |
| 4. non-referential forms | neutral performance |
| 5. literalness | task or task-like activity |
| 6. simplicity | singular action, event or tone |
| 7. human scale | human scale |

13. Working version of chart for
Yvonne Rainer's, 'A Quasi Survey…', 1966.

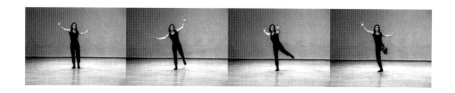

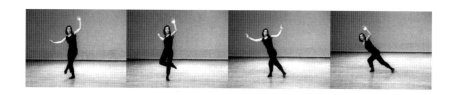

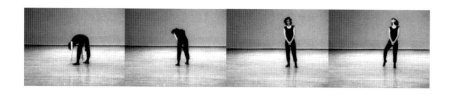

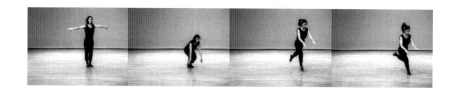

14. Sequence from *Trio A* performed by
Yvonne Rainer, 16mm black-and-white
film produced by Sally Banes, 1978.

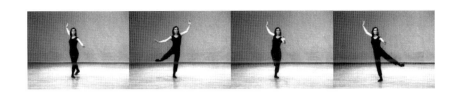

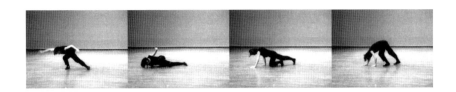

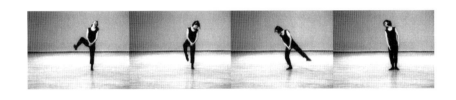

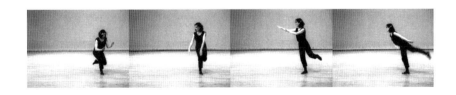

15. Jimmy Robert and Ian White
*6 things we couldn't do and can do now*,
Tate Britain, London, 2004.

exhibition had had to be a retrospective since, as everyone now knew, Pollock could no longer paint.'[80] The artist's apparent anxiety about producing his work in this context was no doubt underwritten by the fact that he had become accustomed to taking his drawings with him to his Jungian analysis sessions, believing them to offer a picture of his unconscious free from mediation. In this art-historical context, the idea of 'authenticity' is defined *against* an instance of performance that involves a conscious behavioural repetition.

Repetition, however, was essential to the choreography of Yvonne Rainer. *The Mind is a Muscle*, like Rainer's previous choreography, was not only built upon sequences of repetitive passages, but it was also very strictly planned, having been developed slowly in rehearsal and performance through the two years prior to the first Judson performance. Earlier works such as *Terrain* (1963) and *Parts of Some Sextets* (1965) also relied on the repetition and variation of set movement patterns and game logic, although the order in which they occurred in the earlier works involved elements of rule-bound improvisation. Richard Schechner defines the essential quality of performance as being behaviour that is 'restored' or 'twice-behaved'. In 'Performance as Metaphor' (1996), theatre historian Bert O. States tested this definition against the conception of an authentic bodily presence put forward in typical writings on the post-Gutai practices known as 'body art', stating that 'Restored' behaviour means that the performer cannot be him- or herself in any immediate sense, only 'beside myself', as in a trance.[81] The notion of authentic

creativity as it was attributed to, and apparently internalised by, Pollock was in marked opposition to the rehearsed, self-consciously performative situation of Rainer's work. Pollock's 'genius', and that of the other artists championed for their transcendent, optical 'grace' by Michael Fried, for instance, relied on a non-visible performance, alone in the studio, in order to create master paintings. It is not unrelated that Fried, of course, detested the 'theatrical' nature of Minimalism, declaring in 1967 that 'theatre [was] the enemy of art'.[82] Rainer's work, rightfully in this sense described by Henry M. Sayre as 'proto-feminist', proposes a different model of image-making altogether.[83]

Rather than dramatising a sense of mute interiority that an individual must struggle to express, Rainer's work appears to propose a simpler, pragmatic materialist notion of authentic experience. In her work, this is to do with her staging of primary relations generated between people in an immediate situation of exchange. In *The Mind is a Muscle*, a community of dancers performed rehearsed tableaux to create images that foregrounded person-to-person relationships. These dances *represented* an idea of spontaneity in the form of improvisation within a rule-bound structure, so as to make transparent the decision-making agency and the 'actual weight' of real bodies, as well as the 'real time' it takes these bodies to go through their 'prescribed motions'.[84] At one level, then, the romantic, patriarchal ideal of the lone creator in the studio that underwrites the notion of male

genius embodied in the myth of Pollock seems to be rewritten in Rainer's work as a pragmatic, materialist authenticity of the body in a matter-of-fact literalness.

However, such an alternative notion of 'authenticity' does not adequately explain the knowing performativity at play in Rainer's work. So often in her writings and her analysis of that work, at the time and since, she speaks not about its 'enduring reality' but about its appearance. The even energy continuum that she presented as work-like fact in *Trio A* requires, she has since said, a great deal of effort that was deliberately concealed in the presentation of the work.[85] By staging the act of spectatorship onstage, as played by the resting dancers, Rainer never lets us forget that what we are watching is theatrical performance. Her work questions the very foundations of any true relationship between authenticity and representation. Feminist theorist Judith Butler links Maurice Merleau-Ponty's phenomenological understanding of the contingency of perception — philosophy that was key to readings of Minimalism — and Simone de Beauvoir's claim that 'one is not born, but, rather, becomes a woman'; this provides a way of linking the relationship of Rainer's understanding of materialism, the body-as-object, to the performativity of her work.[86] As with the contingent perspectives lent by embodied perception in Merleau-Ponty's analysis, Butler writes, 'gender is in no way a stable identity or locus of agency from which various acts proceed; rather, it is an identity tenuously constituted in time — an identity instituted through a *stylised repetition of acts*'.[87] Because of the

performed nature of these gender norms, Butler sees potential for their deconstruction through 'the possibility of a different sort of repeating, in the breaking or subversive repetition of that style'.[88] In other words, the very fact of gender's performed nature means that each individual has the agency to perform it differently if they so choose.

Butler, unlike Rainer, deals with gender specifically, but her model of performative agency is a very useful one in terms of thinking about the manner in which Rainer stages performance as resistance in a wider sense. Rainer has written in retrospect:

*You will ask, resistance to what? It almost doesn't matter. Resistance to previously imposed canons of taste, to imperialism, to patriarchy, to social inequity, to war, to Abstract Expressionism, you name it. However wrongheaded, misguided, naive, ineffectual, enraged, sublimated — a thread is there.*[89]

Butler claims that 'gender is a construction that regularly conceals its genesis';[90] Rainer showed the mechanics of movement, for example, instead of creating spectacular illusion, so as to 'break' the apparently seamless identities of the dancers onstage as 'other' and bring their actions into identifiable experience with the non-dancer (non-specialist) audience watching them. It was within this context that she laid the groundwork for the creation of a new kind of performance, with its reinvented form of continuity, its own resistant logic: *Trio A*.

Rainer's work manifests an inherent understanding of the subject's entrenchment in role-play: her uses of language and gesture may appear to offer primary alternatives to performative 'acts', but in fact they fully understand themselves as the performance of roles between acting agents. Her choice of the concentrated performance space that is the theatre then serves to frame different kinds of acting out as 'culture'. Although these acts are firmly connected to everyday practices and behaviours, they are not predictable or stereotypical. Rainer invented new images of how people might walk, move, dance, perform, interact. *The Mind is a Muscle* may have been 'inauthentic' in Greenbergian modernist terms, not only because it involved rehearsals and took place in a theatre, but also because it proposed a presentation of self that was self-consciously performative. Its enduring significance as an artwork lies in the way in which, from this perspective, it opened up new possibilities for performing the self and sociability that were not culturally pre-scripted.

## 4. The World as a Stage

### Ritual

Sociologist Emile Durkheim identified the theatre site as the generative locus of shared language through forms of ritual. Rainer's choice of the shared space of the physical and conceptual frame of theatre for her work is highly significant to a discussion of subject-formation through the rituals of performative 'acts'. For if the individual creates his or her self through performative acts, the theatre space participates

in the constitution of culture as a concentrated, ceremonial form, existing as a clear frame around a set of social relations or acts for a particular duration of time in a particular place. The introduction of specific objects and rules within the frame provides ways of negotiating or reinventing these relations in a manner that is active and collectively witnessed. Describing Durkheim's perception of the way in which ideology is performed within culture, Anthony Giddens wrote, 'Society, particularly as it is manifest in the collective enthusiasm generated in periodic ceremonial, is the source of new beliefs and representations. Religious ceremonial does not simply reinforce existing beliefs, it is a situation of both creation and re-creation.'[91] Where Durkheim speaks of the actual theatre, Judith Butler uses the notion of 'theatre acting' analogously to describe those performances of identity which constitute a culture:

*Gender is an act which has been rehearsed, much as a script survives the particular actors who make use of it, but which requires individual actors in order to be actualised and reproduced as reality once again. [...] As anthropologist Victor Turner suggests in his studies of ritual social drama, social action requires a performance which is repeated. This repetition is at once a re-enactment and re-experiencing of a set of meanings already socially established.*[92]

Our contemporary understanding of the ritual nature of the theatre derives to a large extent from the observations of anthropologists studying tribal cultures. Considering the 'fetish' as it relates to social ritual

helps to make sense of Rainer's consideration of the relations between image, social interaction and 'work'. Our understanding of the fetish — a term appropriated by Marx and Freud to describe Western habits of ascribing inordinate value to commodity objects — has its origins in William Pietz's analysis of the accounts of sixteenth- to eighteenth-century encounters between European and African traders. European traders misinterpreted the African traders' ascription of value to apparently arbitrary objects such as 'an elephant bone, a whisk broom, a pot of ashes' and took these to be evidence that the Africans did not understand the true value of things (such as gold). In his discussion of Pietz's work, contemporary anthropologist David Graeber analyses the effects that this cultural mistranslation has had on the apparently immutable 'laws of the market' of contemporary capitalism.[93] In the cultures the African traders were coming from, he observes, the fetish was not, and was never intended to be, an object of value in itself. Rather, it was an element of a ritual of what he calls 'making fetish', a means of creating 'new social responsibilities, new contracts or agreements'.[94] The fetish symbolised the power of social relations in material form. Even an image or a person's 'artificially beautiful' appearance could be a powerful fetish, he notes. The notion of 'making fetish' implies 'that by a form of collective investment one can, in effect, create a new god on the spot'.[95] Graeber begins his article by posing the question, 'What is the role of creativity, collective or individual, of the imagination, in radical social change?'[96] He ends by concluding that it is helpful to go back and re-read

the misunderstood notion of the fetish as it operated in these cultures, in order to shift the focus back onto social relations and how ascriptions of value within them might be changed.

Graeber's revised understanding of the relationship between fetishism and social creativity makes sense of Rainer's negotiation of the capitalist realm of the image in her work. Rainer used objects in her theatre pieces, often resembling the Minimalist art objects of her contemporaries. Instead of these fixed entities being ascribed with value, however, they became points of negotiation in the creation of transient, live images with ritual power that compelled the audience to watch them. Rainer, as my reading of Graeber suggests, mapped the notion of the fetish back onto the social contract — between performers, and between the performers and the audience — and within this agreement of physically active and passive constituents created new kinds of 'enactment' and 'repeating', 'beliefs and representations' lent power by the ritualised site in which they took place.

Unlike the Judson, the Anderson Theater, as I have noted earlier, provided a seated auditorium with a proscenium arch.[97] Such a formal theatre situation foregrounded the physical division between audience and performers, and so too the visibility of the social contract that requires a division of roles in such a space. While much twentieth-century theatre, from Bertolt Brecht to Augusto Boal, sought to rouse the passive onlooker to active participation, Rainer acknowledged the manner

in which the audience's passivity exerts a pressure in the form of the demand to be performed to, to be entertained. (Notably, the earliest recorded 'professional' dancers in ancient Greece were often slaves.)[98] In the case of the Judson, this provisional agreement had been delicately balanced, especially because the concerts did not involve proper seating or require the audience to pay for tickets. At the Anderson, however, people had seats and bought tickets.[99] Rainer openly admits that throughout the history of the Judson Dance Theater, and of her own work, people often walked out, unavoidably participating in the performance: 'The only way out of Judson if you were in the audience was to walk across the performance space, and that is what happened [...]. People trudged unhappily [and] disconsolately across that space to get out.'[100] At the Anderson participation was not so literal, but was essential nevertheless.

How can we understand the agency of spectatorship in Rainer's work while the audience was seated at a defined distance? First, Rainer appears to view the spectator's role as 'active interpretation' rather than as passive reception. Asked about her opinion of the audience reaction at the 'Now' Festival in Washington, D.C. in *The Washington Post* on 5 June 1966, Rainer said, 'It was a very lively audience, they booed, clapped, expressed what they thought. Several parts of my piece they had very accurate reactions about.'[101] She continued, 'I don't like a passive audience. There's no reason they should sit there and take it.[102] [...] I'm accused all the time of not caring about the audience. Some people

think the audience is privileged to witness the artist at work. I don't go for that. I want their interest.'
So Rainer used the theatre as a situation of collective witness; collective participation in an event was divided into physically active and passive roles, but was, as a whole, framed as a specific distribution of bodies in positions with reciprocal interest. Second, much has been made of the direct encounter between audience and performers on the Judson floor-plane, but photographic evidence, such as Peter Moore's documentary shots of Rainer's *Three Seascapes* (1961), shows the onlookers appearing somewhat terrified by the encounter, drawing back from proximity with the performers. By inviting her audience into an explicitly unequal situation and yet inviting their attention, their response, their interest, Rainer challenged the audience-performer configurations that had been enthusiastically celebrated as being 'democratic' at Judson, empowering them in a clearer way via an activated capacity for imagination and discrimination; a form of imagination as agency.

I have spoken about the theatre medium in broad, social terms, but it was at the level of her personal subjectivity that Rainer's negotiation of her desire to perform for an audience was a driving force. Her entire project was motivated in part by her attempt to come to terms with her self-confessed exhibitionism. Writing of her very first experience of performing *Three Satie Spoons* onstage at The Living Theater in 1961, Rainer said:

*It was like an epiphany of beauty and power that I have
rarely experienced since. I mean, I knew I had them —
the audience [...] an intense feeling of being in the moment.
It was the first time I had experienced myself as a whole
person. There was no part of my consciousness that was
anywhere else.*[103]

While writing in private led the young Rainer to feel
like a 'fake', creating dances and performing onstage
before a real, present audience appeared to give her
a moment of completeness. It was the performance situ-
ation only, perhaps, that might — for the performing
modern subject that Rainer represented — collapse the
activities of doing and thinking into a single, present
instant. If the mind is a muscle, consciousness cannot
be known unto itself, but can only be demonstrated and
shared via gesture. In Rainer's work, the convention of
the physical mirror in the dance studio was re-charged
via metamorphosis into the live mirror represented by
the crowd, and substituted visually by the distortingly
reflective Mylar across the back of the stage, creating
multiple, kaleidoscopic relations and reflections. Her
crowd-as-mirror was also represented schematically
by the performers who remained onstage watching
others dance, and constituted *en masse* by the real
audience. The question of 'authenticity' re-arises here,
in displaced form; it is not an 'inner essence' attribu-
table to the individual subject, but perhaps something
that might erupt in a situation of exchange, in 'the
interval between identities' that might be opened up
when habitual modes of communication are disrupted.
The question of 'authenticity' might be said to be

displaced from the performer to the audience in Rainer's work. Her material was rehearsed and choreographed and presented. Their reaction was — albeit within certain conventions — improvised and spontaneous.[104] At least, spontaneous reaction during the work is what Rainer hoped for, in place of polite applause at the end.

### Resistance

Although Rainer saw dancing as only 'one factor' in the work, she took dance theatre's particular conventions of movement style and theatre setting as a ready-made ritual, with their attendant expectations and conventions. The codified movement that we might term 'contemporary dance' has evolved extensively over time, from its origins in a kind of ritualistic, 'pantomime' theatre in Ancient Greece or Rome that was then stripped of its pagan bases by the Christian church. By the time of the European Renaissance, dance had been transposed into social diversions called 'balletti'. The balletti was characterised by the composition of performers in changing sequences of floor patterns, which oddly enough had more in common with early Judson dance than with their modern namesake. Balletti were not, for instance, performed by professional dancers, but by members of the court who were trained by choreographers and they were presented 'not on raised stages but in the central space of a large hall, with the audience seated above in galleries around three sides of the space'.[105] It was under France's Louis XIV that performances in court became more elaborate costumed entertainments that would be rehearsed for

an assembled audience, leading to the development of what we now know as 'ballet'. In the United States, modern dance developed in part through the work of Isadora Duncan, who advocated a free approach to 'find those primary movements for the human body from which shall evolve the movements of the future dance in ever-varying, natural, unending sequences'.[106] 'This dancer of the future,' she prophesied, 'will not belong to a nation but to all humanity.'[107] Martha Graham, with whom Rainer took classes, expanded this notion of expressiveness in her angular, ritualistic style, combining references to the modern city and modern subjects with invocations of primitive myth.[108]

Rainer's dance language mixed the influences of her different dance teachers with art and life, as she described it:

*the non-dramatic dance techniques of Merce Cunningham, the philosophical ideas of John Cage, the visual, non-verbal approach to theatre worked out by various painters and sculptors (Claes Oldenburg, Allan Kaprow) in 'happenings' and the ideas of the lately popularised 'pop art' and theatre of the absurd.*[109]

The groundbreaking investigations of audience-performer relations by San Francisco-based choreographer Anna Halprin, with whom Rainer took a summer workshop in 1960 (where she met Trisha Brown), were a highly significant influence. Although ballet and modern dance had by the early twentieth century become entirely separated from the participatory social context

in which they began, dance remains a medium that is potentially porous because of its proximity to other forms of movement and gesture. Rainer radically incorporated a collage of ballet language ('Yes *Trio A* contains three arabesques!' she notes),[110] vaudeville, mime, and rock 'n' roll, as well as walking, running and jumping within her lexicon; showing a body in movement that could alternately be strong, collapsible, graceful, corny and mechanical.

Rainer's own language of dance, of course, was presented within not only the conceptual but also the physical and temporal frames of the theatre. Carrie Lambert-Beatty discusses the way that time is treated in Rainer's work as a 'container' rather than a measure. She invokes the idea of ethnographic task-time — ie., rather than using measured time to structure tasks, 'activities or tasks are used to measure time'. For example, the time it takes to perform a mundane activity might define 'an interval of time called "a rice cooking" or "a pissing while"'.[111] I propose that the mode of resistance in Rainer's work can be defined in terms of both the temporal and the spatial structures — the one hour and forty-five minutes and the theatre architecture — being considered as 'containers' within which she manipulates or elaborates upon (in this case, dragging out) conventional expectations.

Michel de Certeau's discussion of walking practices in the city as a performative enunciation of its potential capacity in *The Practice of Everyday Life* (1980) provides a useful extended parallel for the way that Rainer

builds her choreography from the specific and limited conditions that the theatre situation provides. The analogy can be expanded to examine how her work fills time literally and drags against the particular temporal expectations set in the 'entertainment' situation that Rainer deliberately invoked. De Certeau wrote:

*First, if it is true that a spatial order organises an ensemble of possibilities (eg. by a place in which one can move) and interdictions (eg. by a wall that prevents one from going further), then the walker actualizes some of these possibilities [...] But he also moves them about and he invents others.*[112]

De Certeau uses the example of Charlie Chaplin's absurdly extended manipulation of his walking stick — an everyday object — in relation to his discussion about how the everyday 'user' of the city might subvert its logic in a kind of geographical *détournement* of passage. Just as Rainer's *Hand Movie* (1966) created a miniature choreography of moving fingers, everyday pedestrian behaviour was repeated and group activities tested out in every combination in her choreography. Simple rules provided the basis for minimal movements that would build slowly into sculptural patterns in space and time.

*The Mind is a Muscle* was built from 'phrases and combinations done in unison'; 'interactive and mutually dependent movements' and 'changing floor patterns' were executed in Rainer's 'ordinary' style around the given prop and stage-set elements.[113] These phrases

performatively reconfigured the parameters of both time and space. The choreography was durational and repetitive; the elaboration of tasks in numerous, extended permutations was acted out in order to present an image of changing and constantly re-negotiated relationships. In this sense, Rainer used the physical possibilities and interdictions offered not only by the spatial organisation of the stage, but also by the temporal format or 'container' of the evening-entertainment event. Her invocations of leisure with the intermissions and refreshments served to reinforce the refusal of the dancers to try to entertain; their flatness — often decried as 'boring' — averted, mask-like gazes and lack of charismatic appeal toward the audience served as deliberate evidence of this.

Rainer treated the dance theatre also as a sculptural 'container' of spatiality. The 'light box' that has been a characteristic of the proscenium stage space since the eighteenth century can be seen as a three-dimensional container that is a kind of image-view, but one in which we can nevertheless clearly perceive the solidity of the bodies onstage. This is in marked contrast with the flattened space of television, which, as previously mentioned, Rainer found could so easily be 'switched off, as if after seeing a bad Western'. Moreover, the cue sheet for *The Mind is a Muscle* notes that throughout the piece, the auditorium 'house lights' were switched on and off at each section, drawing attention to the physical presence of the live audience by illuminating them in their seats.[114] In this way, Rainer drew attention not only to the sculptural situation of the

theatre, but also to the fact that the audience is as much implicated in the piece's duration as the performers, whose unhurried pace they take the time to sit through. As with the experience of watching television in one's living room, the audience would have to make a physical gesture that became in itself theatrical, to 'switch it off' by getting up and walking out.

In attempting to define the essence of 'performance', Bert O. States observes that during the Baroque period, as in Shakespearean drama, 'there is no distinction between performing work, performing an office [...] a role in politics or putting on a play'.[115] 'Performance is,' he writes, 'much like the term culture — "the original difficult word" as Raymond Williams puts it, in that it participates in "two areas that are often thought of as separate — art and society".'[116] In Rainer's use of everyday movement as dance, a Baroque parallel is indeed evident.[117] But in the twentieth century the notion of 'performance' has been invested with a psychological emphasis that is anachronistic in terms of the seventeenth-century idea of role-playing, and it is important to bear this in mind in terms of the aspects of Rainer's work that appear to be mimetic.

The simple movements such as lifting, walking, jumping or climbing steps in Rainer's dance lend the work a primary, as though 'neutral', aspect. It is tempting to read the work, and Rainer's resistance to ideology, as an attempt to start 'from scratch' culturally. But the knowing, performative foundations of Rainer's practice (her stage career actually began with James

Waring, who was famous for performing in drag) indicate that her fascination with pragmatism and her understanding of every gesture's inherent theatricality co-existed and clashed in her thoughts and practice. The process of literally 'starting from scratch' in a physical sense may have informed the look of the work, however. After one of her periods of hospitalisation during the time that *The Mind is a Muscle* was devised, Rainer described in a letter to her brother the exercises she had to perform to regain her strength: 'I have had to do a lot of simple operations as though for the first time: sitting, standing, eating, walking [...] I can still hardly walk up stairs.'[118]

It seems that Rainer utilised these experiences as a metaphorical strategy — as with her use of democratic principles — in order to create building blocks toward a different kind of acting and different kinds of role-play. As they lift, hold and partner each other, performing simple tasks, men's and women's bodies are treated equivalently, producing images of dynamic equality between them. Wittgenstein's formulation of the basic form of language in the builders' language game is made visually manifest in actions that occur straightforwardly as exchange. Rainer presents people negotiating relationships that displace the abbreviated roles or characters that society might ordinarily assign them, accomplishing this through a literalness that may not be any more 'true' to the capacities of the individuals who perform them, but that serve, resistantly, to disrupt conventional patterns. Their 'primary' quality also makes the actions clearer and more object-like.

## Protest

If Rainer's work engaged with the Baroque concept of 'the world as a stage' at a conceptual level, the socio-political context in which *The Mind is a Muscle* was made, from the mid-1960s leading up to 1968, was playing it out in a real way. As journalist Marion Sawyer in the *Chelsea Clinton News* put it in 1970, 'The 60s were a remarkable decade for dancing — in dance halls, in concert halls, in the streets.' She continued, 'as social dancing was lending arms to the youth revolt, dancing as a theatre art furnished the matrix for the artistic upheaval of the 60s.'[119] The public stage of action created by the civil-rights movement in the United States and the student uprisings in Paris in 1968, moreover, had a significant impact upon the avant-garde consciousness. This civil protest relating to individual freedom occurred in parallel to a number of anti-Vietnam War protests — a war that was seen remotely, but that threatened the male individual locally, throughout the United States, with military conscription.[120]

Rainer's relationship to ideological political protest was ambiguous at this point. Her statement for *The Mind is a Muscle* claims that 'ideological issues have no bearing on the nature of the work'. In early 1967, however, she took part in the 'Angry Arts' series of 'Dance Protests for Vietnam' at Hunter College Playhouse in New York. The second of these events, in February 1967, included work by James Waring, Aileen Passloff, Twyla Tharp and Deborah Hay, among others.[121] Rainer, just out of a period in hospital, presented her

*Convalescent Dance*, a version of *Trio A* that she
performed in a convalescent condition. Reviewing
this event in *The New York Times*, Clive Barnes remarked
unfavourably on the clumsy attempts of certain
choreographers to make 'political' work, having written
favourably of Rainer's simple presentation of dance:

*The only work in the program to make a direct reference
to Vietnam was Margot Colbert's ballet called just that:*
Vietnam. *It featured a model of a bombing airplane made
up to look like a shark.* [...] *Perhaps it only went to show that
the most effective protests are always to be made by people
doing what comes most naturally to them.*[122]

A year later, then, Rainer explicitly positioned *The Mind
is a Muscle* in contrast to this kind of event. Perhaps
this was an acknowledgment of the futility of dance
as protest, but moreover it proposed the different and
more all-pervasive form of resistance that Rainer has
described since: resistance to any form of ideology, even
the ideology of democratic protest which had become,
to some extent, a form of acceptable mainstream activity.
As a dance writer of the time succinctly put it, 'Without
ignoring the world, Rainer is non-committal in an
overcommitted age.'[123]

It was the simplicity and primariness of movement
in *The Mind is a Muscle* that created its resistance to
ideology. Rainer's eloquent transposition of the energy
of political agency to be found in contemporaneous
activism made her work appear somehow hieroglyphic
or abstracted. 'Watching her is like a riddle', one

reviewer wrote.[124] Where the sloganised beliefs of contemporary politics were set out in linguistic terms that implied their universality — for example, the use of 'we believe' — Rainer's dance formed a different kind of 'we', in that it was visibly local, partial and comprised a discrete number of individuals. Nevertheless, it did represent a kind of proto-community in theatrical form. Rainer wrote of the political aspirations underwriting her work only in retrospect, admitting in 1981 that 'during rehearsals of *Terrain*, I began to have fantasies of a different kind of social structure'.[125] Just as Judith Butler sees the possibility of 'gender transformation' in 'a different sort of repeating, in the breaking or subversive repetition of that style [of performed 'belief' in biological gender identity dictated by the cultural mainstream]',[126] Rainer's performance presented the enactment of relationships that were not proposed by the 'spectacle', but that offered a 'different sort of repeating'. Like her teacher Anna Halprin, who said in an interview with Rainer in 1965 that she was trying 'to eliminate stereotyped ways of reacting',[127] Rainer's dancers danced an intelligible demonstration of the thinking, acting, fallible human subject with agency to perform culture.

Rainer's aesthetic form resisted adherence to any pre-existing, normative ideology, 'democratic' or otherwise. *The Mind is a Muscle* was a succession of movement tableaux that presented seven people relating to each other in a direct sense via the negotiation of generic objects (mat, steps, trapeze), with funny or vulgar eruptions of gender-play (she grabs him between the

legs, he grabs her chest). In this way, Rainer presented a new, primitive language game in physical form that implied an expanded potential for (per)forming new kinds of sentences, most importantly the complex construction of *Trio A*, from a new alphabet of social roles and relations.

### 5. 'Ne Travaillez Jamais!'

### Work

In a letter to her brother Ivan dated 1 January 1966, the year in which she made *The Mind is a Muscle, Part 1*, Rainer lists what she describes as 'a short hierarchy' of her interests:

1. making dances
2. spending money
3. sex
4. vacations[128]

Although dancing as a social activity had become increasingly popular in 1960s America, 'making dances' was not likely to have been something in which the ordinary person was engaged. The unabashedly profligate nature of the other three 'interests' on Rainer's list are surprising, however. She was perhaps playfully attempting to shock her brother with this flagrant embrace of decadence; he, like her, had grown up with socially conscientious parents who, she recalls in her autobiography, were drawn together by their shared interests in 'radical politics and vegetarianism'.[129] Rainer's diaries, and the extensive correspondence

between the siblings, demonstrate that both manifested sophisticated political awareness from an early age.[130] In a previous letter to Ivan, Rainer had confessed, 'Hardly a day goes by but in some form or other I am overwhelmed with the realisation of being one of the really privileged of this earth.'[131] This statement of her 'hierarchy of interests' is fascinatingly leisure-orientated, then, especially in relation to the fact that she characterised the core concern of her dance aesthetic in terms of 'task' and 'work'.

Asked by Willoughby Sharp and Liza Bear in a 1972 interview for *Avalanche* magazine why she used 'task' to describe an alternative form of movement, Rainer explained that this decision was *not* made for its structural organisation. 'The organisational battle had been fought for the most part by Cunningham and Cage, as far as I was concerned. They had dealt with the problems of theme and variations and A—B—A and development and climax by introducing indeterminacy as a compositional device.' Her own interest, she continued, was with 'the idea of task and a more concrete, autonomous-looking life on stage'.[132]

In her text 'Quasi Survey of Some "Minimalist" Tendencies in the Quantitatively Minimal Dance Activity Midst the Plethora, or an Analysis of *Trio A*' (1966), Rainer writes of her 'factual' style of choreography:

*What is seen is a control that seems geared to the actual time it takes the actual weight of the body to go through*

*the prescribed motions, rather than an adherence to an imposed ordering of time. In other words, the demands made on the body's (actual) energy resources appear to be commensurate with the task — be it getting up from the floor, raising an arm, tilting the pelvis, etc. — much as one would get out of a chair, reach for a high shelf, or walk down stairs when one is not in a hurry.*[133]

If one failed to note the presence of the words 'seem' and 'appear' in the description, this essay, which describes her interest in 'movement as task or movement as object',[134] read in parallel with the non-hierarchical images of her 'democratic' choreography, might lead the reader to the conclusion that despite the work's rejection of ideology, her dances had a strongly Marxist underpinning. Indeed, the title *The Mind is a Muscle* and the work's insistence on the equivalence between apparent and real energy without extraneous choreographic ornamentation play out in physical form the idea of real labour power over surplus value. More literally speaking, her representation of tasks created images that depict 'labourers' who, if not heroic, are certainly empowered and thinking. Dance theorist Randy Martin has described Rainer's work in these Marxist-socialist terms, concluding that 'In the face of all-consuming market rationality, a movement that has no other purpose than to allow people to gather to reflect on what they can be together is perhaps the supreme figure of an ongoing desire for socialism.'[135]

Rainer's choreography of *Mat, Stairs* and *Act* in *The Mind is a Muscle* might well be interpreted as the assertion of

an antidote to the picture Marx painted of the alienated capitalist worker who 'has no clear conception of a unity of purpose which binds his activity together with the collective productive endeavour of society'.[136] According to Marx, the specialisation of work is therefore equally a symptom of alienation, as it isolates the individual who is no longer identified as a member of society, but as the representative of a special trade. So Marx writes that 'occupational categorisation makes a specialised work task the principle social quality of an individual (a man "is" a teacher or "is" a wage labourer)'.[137] In her movement sequences that used generic forms of task, game and dance to simply 'reveal' people as they are, alone and together, Rainer could thus be understood to evoke a number of Marxist ideals. First, she touched on the ideal of unalienated 'work' by foregrounding the self-awareness of the performer (or 'worker') and de-emphasising the status of the performers as 'specialised' dancers. Second, dance-as-work was performed collectively, with each participant actively constituting and understanding the outcome of his or her movements within a certain set of rules set by the choreographer. Each set of relations relied on a visible chain of local physical causes and effects among the performers onstage.[138] For example, in *Stairs*, a sequence of interplay between the three dancers listed as Section III is described thus:

*Steve handstand — David grabs his legs while Y gets foam, places, rolls down, D and S come front, push mat as D and S rejoin Y, breast-hold while she alone walks up and jumps. S and Y replace foam, S and Y help D somersault up;*

*Y removes mat as S moves stairs to upstage centre (while D does leg and knee sits).*[139]

Finally, the idea of staging basic physical actions that nearly anyone could perform — and, later, the widespread teaching of *Trio A* — challenged the idea of the 'specialist' dancer for a broader public who could actually participate in performing it.

Early experiences recorded in her diaries show Rainer to be naturally fluent with socialist politics, and also provide insight into her immediate perception of concurrent social history. In an entry on Thursday 17 May 1951, she records a school trip to the Victor Equipment Company. Within this factory, she notes, 'I found that I was not interested so much in the machines as in the operations. [...] All day long they stand there, turning something here, pushing something there, and so on. [...] they could probably do it without looking.' She continues indignantly, describing the 'fat president sitting back in his swivel chair and laboriously telling us what a democratic organisation his is [...] do many think of what actual goods they are producing for man's subsistence [...]? I don't think so.'[140] In the year following her visit to the factory, Rainer records observations about her working neighbours, a taxi-cab driver and his wife:

*Every night [...] they sit down to dinner, then wash the dishes. Afterwards they play cards or listen to the radio. [...] they never engage in discussions about religion or philosophy or politics or art or literature [...] who are these people?*

*They seem to be content — without education, knowledge, erudition, insight [...] without intellectual stimulation.*[141]

Rainer berates herself for her relative complication of things, wondering whether she might not derive greater satisfaction from 'mere everyday existence'. She tells herself that she could not, but she is clearly fascinated with the idea.

In one sense, then, Rainer's pedestrian choreography as presented in *The Mind is a Muscle* appears to be an attempt to lose her thinking-self in the factual business of ordinary activity as though she were an 'ordinary person'. The clothes worn by the performers in the piece are described, too, as ordinary, although photographs taken of Rainer around the same time reveal her in patterned and printed dresses that are not the studiedly casual jeans and sneakers that became the costumes in her dance. The simplicity of her movement's repetitive, minimal forms finds value and beauty in an idealised notion of 'everyday existence' that did not literally represent the nature of work in an increasingly industrialised America.

The socialist reading of Rainer's work is seductive, but it is too straightforward to accommodate the virulent performativity that is always at play. As is indicated by the studied nature of the 'ordinary' costumes, the choreography of *The Mind is a Muscle* has much more to do with image and illusion than Rainer's discussion about work, task and the elimination of stylisation seems to admit. In conversation, Rainer told me just

how much concentrated effort it requires for the dancer to maintain the appearance of an 'even energy continuum' that she equates in her chart with 'factory fabrication'. Despite the parallel compositional approaches between this dance and Minimalist sculpture, the complexity of a live body in relation to an inert object cannot, of course, be suppressed. The 'gestalt' perception against which Morris tested the variation of shapes in his 1965 installation *L-Beams* could not truly be paralleled by bodies performing dance movement, or even by bodies being moved by someone else. Rainer, in any case, made more explicit the complicatedness of her relationship to 'energy' in the work, distinguishing between 'apparent' and real energy, 'what is seen in terms of motion and stillness rather than of actual work, regardless of the physiological or kinaesthetic experience of the dancer. The two observations — that of the performer and that of the spectator — do not always correspond.'[142] She continued, 'the irony here is in the reversal of a kind of illusionism: I have exposed a type of effort where it has been traditionally concealed and have concealed phrasing where it has traditionally been displayed.'[143] As she said in a discussion about her recent work *AG Indexical* (2006), the onstage position lends a degree of self-consciousness so extreme that even in the short section where the dancers were instructed by her to 'meander' or 'do next to nothing', 'it is in fact incredibly difficult to appear, naturally, to be "doing nothing"'.[144] The whole situation of Rainer's work is 'shot through' with performativity, rather than being, straightforwardly, the action it appears as, or even straightforwardly mimetic.

## Leisure

What, then, is at stake in this illusion? What was meant by this performed representation of non-productive labour in *The Mind is a Muscle*? The nature of the choreographic 'work' becomes more challenging in light of certain economic facts. If we return now to the image of the distribution of people and activities that make up the social fabric, and to the question of how this distribution makes for a functioning 'society', it is essential to consider that while Rainer represented or *performed* 'work' in her dances, she seldom, at this point, worked for a living. Aside from the receipt of individual project expenses, and later some money from teaching, Rainer had virtually no income from her choreography or dancing. Life was considerably cheaper in New York at that time, and like many of her contemporaries, she was able to survive on very little. However, Rainer was in a position of privilege, in that she was for much of the 1960s supported by her parents through relative wealth gained directly as a result of their part in the transition to capitalism that created the booming economy of post-War America.[145] Rainer confessed in a letter to her brother in 1966 that she had not filled out a tax return in eight years, and that she saw herself in financial terms as 'invisible'.[146] *The Mind is a Muscle* programme sheet thanks the Guggenheim Foundation for enabling her to continue with her practice by the award of a recent grant. Having a private income has not been unusual for artists throughout history and need not have any relevance to the work. However, as is evident in the extract from her letter at the beginning of this chapter — and, as I will demonstrate, in her

work — this doubling of explicit demonstration and invisibility, of labour and privilege, is evidently, in light of the persistently autobiographical drive in Rainer's work, a productive source of conflict.

Even before we consider the fact that Rainer labelled the content of her work 'work-like', the overlap of the very word 'work' to describe an artist's practice is a complicating factor in an analysis of how that practice fits into society in an economic sense. *The Mind is a Muscle* presented groups of people dancing images of 'labour': carrying bulky objects, picking them up, putting them down; lifting each other; running and walking in groups that were paralleled visually with a herd of antelope seeking food in the bush, or with the automated workers in Fritz Lang's *Metropolis*; 'working out' their bodies gymnastically and working through an entertainment-inflected 'act', complete with trapezes and magic tricks. Rancière writes about how artistic work relates to the role of work in society with reference to Plato, who saw the role of the actor in particular as problematic because he was 'a man of duplication, a worker who does two things at once'.[147] Concluding that 'the mimetician provides a public stage for the "private" principle of work', Rancière deduces that 'thence, artistic practice is not outside of work but its displaced form of visibility'.[148] 'Whatever might be the specific type of economic circuits they lie within,' he writes, 'artistic practices are not "exceptions" to other practices. They represent and reconfigure the distribution of these activities.'[149]

It is at this point that the double-edged position articulated by Rainer in *The Mind is a Muscle* becomes most clear. On the one hand, she creates an abstracted indication of the 'labour' that she sees all around her in everyday life, in a manner that she describes as having a 'factual' rather then 'mimetic' quality (ie., it is a conceptual transposition, not an illustration).[150] At the same time, however, to combine Butler and Rancière's terms, she performatively displaces and reconfigures the premises of the post-War Fordist working culture by representing labour as an aesthetic end in itself, as a form of energy consumption that negates the demands of productivity.

Rainer made dances that she called 'objects' representing 'work', but — deliberately — did not make any saleable *product*. Like the dancers' bodies, the 'objects' are charged with a ritual presence and thus they become, in the openly creative sense that Graeber writes about, fetishes with ever-changing meanings that are explicitly not for sale. Moreover, her 'unhurried' work inserts itself as a mode of slow-to-consume resistance within the capitalist economy that goes against its drive toward productiveness. Of her earlier work *Parts of Some Sextets* (1965), which was essential to the development of *The Mind is a Muscle*, she said that its effect of 'repetition of actions, its length, its relentless recitation [...] combined to produce an effect of nothing happening'. It was 'like a 10-ton truck stuck on a hill' or 'like a treadmill', she continued.[151] And yet at the same time, she used that very same word to describe her dislike of 'the touring treadmill' that could earn

her money by treating 'performing as an end in itself'.[152] Operating from the relatively privileged position of living on the surplus of an affluent post-War America, Rainer chose not to 'capitalise', but exhibited her determined resistance to the logic of affluence through a flagrant wastefulness.

Rainer's community of dancers who perform this 'work' perform an attitude akin to that of the proto-'slacker' group of artists with whom Guy Debord was associated in 1950s Paris — 'the tribe' from whence the Situationist slogan 'Ne Travaillez Jamais!' (Never Work!) came. Although her choreographic patterns involve 'goal-oriented' strategies, *The Mind is a Muscle* flaunts the participants' luxury — their ability to choose not to spend time as slaves to the capitalist work ethic, to demonstrate 'work' as a game, an aesthetic activity. It was, akin to the Situationists' 'Economy of Desires', a means to inhabit time and space in a pleasurable way, to create symbolic images of 'high thinking' as labour, to engage in non-productive (and while sexually playful, non-*reproductive*) physical relations.

In his 'The Theory of the Leisure Class' — a satire about status and wealth in early capitalist America first published in 1899 — Thorstein Veblen defines 'leisure' as a term that 'does not connote indolence or quiescence. What it connotes is *non-productive consumption of time*.'[153] Veblen's famous chapter on 'conspicuous consumption' describes the way in which affluence is demonstrated by the aristocratic classes in society via the adoption of non-productive activities that parade

the subject's abundance, not of wealth, but of time
to practice and learn them. He lists such activities as
'knowledge of dead languages, occult sciences, of correct
spelling, of the latest properties of dress, or furniture
and equipage, of games, sports and fancy-bred animals.'
'Vulgarly productive occupations are unhesitatingly
condemned and avoided', Veblen wrote. 'They are
incompatible with life on a satisfactory spiritual plane
and with "high thinking".'[154] In Rainer's conception
of the mind as muscle, the acting-out of that 'manual
labour' and 'everyday work' shunned by the upper classes
in Veblen's terms is provocatively presented as dance
— a decadently non-productive activity. Her provocation
therefore has a double edge: by staging work as dance,
she displaces labour from the context of mundane
economic reality into a sphere of a 'non-productive
consumption of time'. Yet, by interpreting dance as
work, she also displaces ballet and reconnects it to
the world of everyday performance.

Veblen's model of the consumption of time, rather
than the specific economic class he analyses, serves
as a useful parallel for understanding the slowness,
'uselessness' and duration of Rainer's work as a form
of resistance. Contemporary dance itself was and
is, arguably, one of the most fundamentally useless
activities in a market sense. Rainer herself spoke of
it in critical, pseudo-aristocratic terms, as 'the most
isolated and inbred of the arts'.[155] So far as the economy
goes, it is not only without saleable object, but today
as much as then it also relies heavily on subsidised
funding in order to exist. Rainer's choreography doubles

back upon the association between work and production by creating an aesthetic form of 'work' at a confrontational remove from any relation to the economy in a real sense, fetishising only its own ephemeral appearance in a provisional, mutually agreed-upon power dynamic between consumers and producers. *The Mind is a Muscle* presents the enactment of the motions of labour as a fundamentally decorative aesthetic in the representational space of theatre, so as to assert a space that is free from the dictates of capitalism.

Rainer's 'work', then, simultaneously played out in a literal form Debord's theory of the all-pervasive spectacle as 'a social relationship between people that is mediated by images',[156] and proposed an alternative to it by inhabiting the image in a primary sense with a new language of gesture. Like her non-productive consumption of time, Rainer's retelling of the ready-made theatre-entertainment situation as 'image' on a local, perceptible level created new, powerful images with bulkiness and awkwardness in direct opposition to the seamlessness of the unobtainable spectacle. The non-productive 'work' that was made visible within *The Mind is a Muscle* proposed that resistance to productivity is the same as resistance to spectacle. By performing work as a kind of 'drag', she reconfigured the relationship between 'work' and 'leisure', collapsing them into a charged, single — but not unifiable — space. Her actual economic invisibility permitted her this visibility to create images in a displaced cultural sphere.

It is this aspect of Rainer's work that most clearly points to its explicitly theatrical or performative, rather than illustrational, nature. The work-like basis of *The Mind is a Muscle* enunciated new capacities for subjectivity in the intervals between the apparently opposing categories of 'specialist/amateur', 'work/leisure' and 'industry/entertainment'. As in the 'zone of the fetish' that Graeber describes, the entanglement of material objects and social relations that Rainer depicted onstage created a world in which 'nothing was fixed':

*a world of almost constant social creativity; in which few arrangements were fixed and permanent [...] in which [...] people were indeed in a constant process of imagining new social arrangements and then trying to bring them into being. Gods could be created, and discarded, or fade away, because social arrangements themselves were never assumed to be immutable.*[157]

Graeber is analysing cultures in which magic and spirituality play a part in this kind of ritual. Rainer made work in a culture in which such ideas were rationally repressed, and yet illusion is toyed with frequently, from the apparent — but feigned — presentation of her task-like 'even energy continuum', to the juxtaposition of her dancers' moves with Harry De Dio's magic tricks. Her understanding of the suspended disbelief at stake in the operations of the 'mechanics of enchantment' that Graeber describes is in evidence everywhere in the way that she harnessed the power of the image.

## 6. A Flourish: The Economy of *Trio A*

### Expansion

In the picture that I have drawn of the world in which the theatre presentation of *The Mind is a Muscle* happened, Rainer's choreography occupies a triple-fold place. As art, it is the 'displaced form of visibility' of the activity of work described by Rancière;[158] its aesthetic also creates a transposed *representation* of work, and yet it performatively flaunts a refusal of the necessity to engage in productive work as an economic means or end. For these reasons, the work does not easily fit in the distribution of constituent parts of the social fabric. But things get more complicated still when we consider in more detail the isolated dance sequence *Trio A*, which was at first known as *The Mind is a Muscle, Part 1*, and around which the rest of the evening-length programme was built. In making *Trio A*, Rainer said she did not know exactly what she was looking for, except that transitions should be unpredictable and should not rely on obvious kinetic development; 'each piece of movement would be very different from every other piece and nothing would repeat',[159] she said. She worked on *Trio A* alone for six months in 1965 before presenting it at the Judson Church from 10—12 January 1966 as *The Mind is a Muscle, Part 1*, danced by herself, David Gordon and Steve Paxton, 'simultaneously but not in unison'.[160] It was in the 'interim' version of *The Mind is a Muscle* in May 1966 that *Trio A* was performed by Peter Saul as an early rendering of *Lecture*, in 'a balletic solo version, ie., with pirouettes and jumps'. Although she had used the sequence of movements that make up

*Trio A* in multiple situations and performances since first presenting it in 1966, as I have described, it was after the Anderson Theater performance that Rainer began teaching *Trio A* to non-dancers. She said, '*Trio A* was the dance I referred to when I said I was a post-modern dance evangelist. It was quite difficult — it had a great deal of nuance and technical demands — and I wanted to teach it to the world.'[161]

The length of the *Trio A* dance sequence is between four and five minutes, depending, according to Rainer, on 'the performer's physical inclination'.[162] Unlike much of the movement that made up *The Mind is a Muscle*, and despite Rainer's claims for its 'factual' quality, *Trio A* is clearly *dance* in its invention and complexity. Despite its unpredictable transitions, the piece is designed to appear fluid and continuous: hands, head, feet and limbs are directed in precise ways as a constant unfurling of the body in space. Moving in so many different directions and configurations, the performer of the piece appears to be attempting — like Chaplin's elaboration of walking with his stick — to expand or maximise the potential for inhabiting the space available to him/her as fully as possible, in a considered and beautiful way.

The opening minute of *Trio A* alone contains a complex number of unquantifiable movements and transitions. It begins with the dancer facing upstage left, her arms hanging by her sides and swinging around her body. This movement then appears to lead her to rotate her arms, extended out from the shoulders, before she steps backward and bends her body into a half-circle shape,

as though hunched toward the floor. This position is then transformed into a semi-balletic movement in which the left leg is extended backward, pushing toward the back wall. She touches her forehead with her hand and points to the floor before her body drops down onto the floor, immediately pressing up again in order to stride to one side, hands clasped and elbows held tight against her chest. The dancer traces a movement with her left arm to make a circle around the body, arriving in a new position, whereby she does a full bodily turn with arms extended. The dance progresses in this fashion, in movements that are never discrete and clear, but finely spun into a single complex thread that draws in multiple associations, from the suggestion of a body trained in exercise classes to slapstick to mechanical movement to ballet. Space around the dancer is grabbed voluminously as she progresses slowly forward with arms revolving around the head and body, as well as vertically as she stretches upward, and horizontally as she points her leg backward or rolls on the floor. The floor area is extensively covered, even by a single dancer. As Rainer describes it, 'If all the trajectories of the dance were laid out on the floor, they would comprise for the most part straight lines in 45-and-90 degree angles with a few connecting arcs.'[163] Carrie Lambert-Beatty has analysed the way in which *Trio A*'s structure as a continuous stream of movement without breaks or still moments deliberately eludes photographic capture as still image. Rainer herself said, 'My *Trio A* dealt with the "seeing" difficulty by dint of its continual and unremitting revelation of gestural detail that did not repeat itself,

thereby focusing on the fact that the material could not easily be encompassed.'[164]

In this sense, it is all the more pertinent that *Trio A* became not just a piece of choreography that Rainer would stage as a performance, but also an 'editioned' artwork taught person-to-person as a kind of code. Although it has been captured on video and in numerous photographs, its real transmission has been as a form of living archive. Rainer first actually taught *Trio A* to a non-dancer named Frances Brooks in 1968. Brooks performed it the same year during a lecture-demonstration at the New York Public Library for the Performing Arts. In 1969, it was performed by six dancers to a popular music track at the Billy Rose Theater in New York City; later that same year, Rainer and a number of the Judson dancers, including Becky Arnold and David Gordon, were in residence at Connecticut College, where they taught *Trio A* to 50 students who performed it, as Rainer recalls, 'in relay fashion for over an hour in a large studio for an audience that was free to roam to other events in the same building'.[165] It was taught as a protest dance in 1970, and was danced by five naked dancers (members of 'the fledgling Grand Union')[166] wearing American flags tied around their necks at an event called 'The People's Flag Show' at the Judson Church. From this point, the teaching of *Trio A* proliferated as the number of people who had learned it directly from Rainer exponentially increased. In the 1970s, Rainer notes that artist Michael Fajans, who had learned *Trio A* from Barbara Dilley, taught it to 50 students at Antioch

College who performed it on a large stage to Wilson Pickett's 1965 track 'In the Midnight Hour'. The piece was recorded for television in 1979 and was performed in a Judson Revival by Rainer herself in 1981.[167] I have seen *Trio A* performed in a number of ways: danced by Yvonne Rainer in a 1978 film recording made by Sally Banes (fig.14) as taught by Rainer to Richard Move performing as 'Martha Graham' in Charles Atlas's video *Rainer Variations* (2002); by artists Jimmy Robert and Ian White, non-dancers who learned it from Pat Catterson (who herself had learned it from Becky Arnold and Barbara Dilley in 1969) as a part of their performance *6 things we couldn't do and can do now* at Tate Britain in 2004 (fig.15); in part by Pat Catterson and others with Rainer as part of 'Wieder und Wider' at MUMOK/Tanzquartier in Vienna in November 2006; and by a group of students at the Laban Centre in London, who learned it as a part of their historical studies under the direction of Martin Hargreaves in 2006.

Rainer's work, as it was embodied as a succession of live tableaux in *The Mind is a Muscle*, and as it has since been transmitted as *Trio A*, provides a form of image-making and a dematerialised aesthetic economy that not only was radical in its time, but that also anticipated (and still challenges) the practices of succeeding generations of artists. In *Relational Aesthetics* (1998), Bourriaud has argued that experimental, participatory work in the spirit of Rainer's performances and those of her contemporaries was explored anew by the generation of influential artists of the 1990s who took as their subjects 'the realm of human interactions and its social

context, rather than the assertion of an independent and private symbolic space'.[168] Bourriaud observes that 'artistic praxis appears these days to be a rich loam for social experiments, like a space partly protected from the uniformity of behavioural patterns'.[169] As a model, a piece of theatre, *The Mind is a Muscle* can be seen both as an important precedent for these practices and as a work that pre-empts the difficulties posed when the artwork *requires* and relies, as a part of the constitution of its own image, upon voluntary, autonomous participation. In her work, rather than claiming any generalised notion of inclusivity, Rainer created complex *images* of social relations that *challenged other images* (advertising images) with consumerist agendas.

Bourriaud wrote of a kind of 'microtopian' activism possessed by the 1990s generation, saying that 'the role of artworks is no longer to form imaginary and utopian realities, but to actually be ways of living and models of action within the existing real'.[170] Rainer's work prefigures and complicates this aim by connecting 'the utopian' and 'the real' in an unprecedented way: by creating and teaching the patterns of dance choreography on the one hand, which conflate the existing real (body) with the imaginary utopian (the dance idea), and on the other hand by simultaneously framing 'ordinary' movement so that the real (a person walking or jumping or climbing stairs) is brought perceptually, and disruptively, into the realm of the utopian (the artificial frame of the theatre). But radically, Rainer also conceived of media culture as a facet of 'the real'; she not only created images, but also dealt with a world

that was partially *constituted* by the image. In creating compelling images of relations between people negotiated via ordinary objects that connected the performers to the everyday masses and to everyday entertainment culture, *The Mind is a Muscle* opened up 'the interval between identities' that Rancière has said might 'reconfigure the distributions of the public and the private, the universal and the particular'.[171]

To highlight the critical edge of participatory work, Bourriaud analysed its 'relational' nature by taking the autarkic economies of barter and exchange as a model whose ceremonial nature anthropologist Marcel Mauss examined in *The Gift*, his 1923 study of gift-giving and hospitality.[172] Indeed, Rainer's decision in the 1970s to distribute this editioned 'object' of her aesthetic for free via teaching it to others might, in retrospect, be read in the same way.[173] Mauss posited 'the gift' as a form of exchange with ritualised conventions in certain tribal situations, partly in order to reflect upon the reciprocal practices of gift-giving within Western society. As a model, this concept of an exchange that transcends a conventional economy can usefully be applied to alternative forms of art practice.

In a group performance situation, *Trio A* serves as a kind of matrix that deliberately foregrounds the individuality of the performers dancing it together, countering the ideological fantasies that underwrite the *corps-de-ballet* tradition of exact sameness, the 'mass ornament' that Siegfried Kracauer identified in early twentieth-century music-hall entertainment

or Nazi military display. As Rainer put it, 'small discrepancies in the tempo of individually executed phrases result in the three simultaneous performances constantly moving in and out of phase and in and out of synchronisation. The overall look of it is constant from one performer to another, but the distribution of bodies in space at any given instant changes.'[174]

As a series, however — as a connected chain of movements transferred by teaching from one body to the next — *Trio A* operates to challenge the cultural field in a different way. Rainer's recollection of a formative experience at the theatre helps in understanding the political imperative behind her early 'evangelism' about teaching the piece. She recalls that she was 'hypnotised' at age 15 by a girl dancing in yellow shoes onstage. But, she wrote:

*I might as well have been watching her on Mars through the wrong end of a telescope. It never entered my head — even in fantasy! — that I might be that girl […] so ignorant was I of the possibilities — in myself, in the world […] to me that dancer was an a priori phenomenon. […] there she was — a complete entity, no history, no sweat, no tears. She hadn't arrived there, she simply was there. […] I was here in my seat and always would be here.*[175]

By teaching *Trio A* to non-dancers, Rainer was able to impart the power of that onstage position to anybody and everybody who wanted to learn it and could then inhabit it.

I have discussed how the community of participating dancers who performed Rainer's language of gestures and movements with each other onstage represented a new form of 'culture', and how the way in which she subsequently shared and allowed for the transmission of *Trio A* represented an expansion of that culture. While Rainer's previous dance was, as I have observed, celebrated for its democratic representation of the 'everyday', many reviews and written responses to it reveal that so-called 'ordinary people' were often alienated by it, expecting to witness skill onstage. *Trio A* proposes, inversely, that skill, grace, nuance and fragments of dance history can be taught to 'anybody and everybody', can open up the space of performance for them, diverting their own movement trajectories from functionality or predictability. It is in this way that Rainer's gift worked to expand — or pervert — the parameters of the existing American culture in which it operated, via its appeal to work outward and include people who were previously excluded. It had to emerge from the critical context of Rainer's own practice to be able to work as a form of celebration of potential. *Trio A*'s graceful, 'unhurried' leisureliness and pure aesthetic form expand and extend movement-time outside of the usual frame of activity that one might engage with, bending, distorting, extending one's experience of the body in space in new and curious ways.

In the 1970s, Rainer's evangelistic gifting of *Trio A* broke and expanded upon the culture in which it was formed, as well as intervening in the economy of the culture it infiltrated. Her decision to teach *Trio A* to

dancers and non-dancers alike proposed this expansion of culture via an unprecedented and unexpected form of giving. Its teaching also presented a challenge to the idea of 'specialisation' that Marx condemns and, as Rancière points out, actually underwrites the delegation of power to elected leaders in the representational nature of today's globalised, democratic politics. However, in recent years, Rainer's evangelistic desire has altered in dynamic tension with a conflicting desire for the work's correct preservation. If *Trio A* is to be understood as an aesthetic 'object', its shape, form and appearance are, naturally, specific and must be maintained as such to prevent the choreographic sequence from becoming meaningless though distortion.

Discussions of its parallel performances and its multiple, fragmented existence as recording imply that *Trio A* is a work that can never be 'known' as such, only compared and learned, contingently performed and approximated. And yet, it exists as a 'score' in an utterly specific form in the artist's own conception. An attempt at its 'correct' preservation was recently realised with its transcription by Melanie Clark and Joujke Koulff in 2004 into Labanotation.[176] The notational score could theoretically be used to reconstruct the dance, and exists alongside its other manifestations: straight video document, 'taught' video document with spoken commentary, written description. The exactness of the Laban score is important to Rainer, who is deeply unsatisfied with the idea of anyone learning *Trio A* from the video: 'The 1978 film reveals someone who can't *plié* properly, can't straighten her

legs etc.'[177] And yet the notation, too, remains inadequate in Rainer's mind. Seeing a performance of *Trio A* derived from the score only, Rainer wrote, 'though I admired their efforts, Pat Catterson, Emily Coates and I worked our asses off making corrections.'[178]

In his book *Hypermodern Times* (2005), Gilles Lipovetsky argues that since the transition to what was known as 'postmodernity', a modern — and now hypermodern — logic has prevailed that rests upon the three elements constitutive of modernity itself: 'the market, techno-cratic efficiency and the individual'.[179] The reliance on far-reaching networks of communication and exchange is a fundamental aspect of this perception of our time. *Trio A*'s existence in material form (ie. as dance) is also founded upon a network of relationships that enable its transmission, but Rainer's insistence on the importance of detailed one-to-one teaching prevents the work's acceleration to hyper-dissemination in any familiar technological sense. Rainer's ultimate dissatisfaction even with *Trio A*'s enactment from a video source or a notational score means that it retains a stubborn material, 'local' weight. It should also be noted that Rainer, or her appointed teachers for *Trio A*, now do receive payment, and that these days Rainer receives a royalty when the piece is performed.[180]

These observations concern the dissemination of *Trio A* body-to-body in contingent, materialist terms, but the existence of the different forms of documentation and Rainer's exactness complicate its continued existence beyond the simplicity of the 'oral tradition'.

This particular sequence from *The Mind is a Muscle* thus manifests the productive but irresolvable tension between materialist and conceptual concerns in Rainer's work. A conflict between art as idea and art as object is made visible, as Rainer has described it: '[teaching it to non-dancers was] not a transcendent moment but a material moment — you saw the material of a struggle in front of your eyes'.[181] Judith Butler argues that normative 'cultural fictions' are formed through the 'sedimentation' of rehearsed scripts, repeatedly performed over time. The dynamic equilibrium at stake in the persistence of *Trio A* between 'script' and 'performance' might be read as a model for the inevitable struggle to establish new elements of culture in the making — to create 'new gods', in ritualistic anthropological terms. Rainer's investment in preserving the piece's exactness is a part of her understanding of how performative enunciation and repetition constitute culture, and how cultural power is maintained. The tension in her work is hinged here: its democratic impulse strains against its specificity as an 'object' that only makes sense if it is precisely formed. Although Rainer's belief in the ability of non-dancers and dancers alike to learn *Trio A* persists, its correct repetition is necessary if the piece is to become embedded in, a part of, or sedimented within the cultural memory as an aesthetic object.

For Bourriaud, 'Could I exist in the space that it defines?' was a key question to pose of artwork in the 1990s. Rainer's work poses a more complicated question: not only 'Can I exist?' within the work, but also

'How does the work *transform* mere existence into something different?' By learning a specific dance sequence, the person that engages with *Trio A* inhabits and performs Rainer's aesthetic as a form of 're-telling'; a kind of *détournement* of everyday experience. Picture *Trio A*, the first and formative element of *The Mind is a Muscle*, not in the vast field of bodies characteristic of the modern city with which I began, but as an infinitely expandable person-to-person thread that can travel, via mind and body, through time. *Trio A* persists as a rare instance of defiant aesthetic celebration planted in the world, flourishing in a perpetual state of struggle between transience and fixedness, materiality and idea.

1
There were seven performers plus Harry De Dio, who came on to perform the magic act in *Act*.

2
In correspondence (by email, 18 March 2007), Yvonne Rainer estimates that the total audience for the three nights could not have exceeded 500.

3
It occurred to me while writing this that this perspectival view echoes Charles and Ray Eames's *Powers of Ten*, which was — coincidentally — made in 1968.

4
Diary entry, Tuesday 25 November 1952, 'Notebooks 1949–52', Box 1, Rainer archive, Getty Research Institute.

5
It is important to note that alongside photographs by Peter Moore the clearest visual record of the most significant piece of choreography from this 'evening-length work' (as Rainer described it), *Trio A*, exists in the form of a filmed *reconstruction* organised by Sally Banes and danced by Yvonne Rainer in 1978.

6
The question of the 'fetish' will come up in reference to the relationship between Rainer's dance and work by her contemporaries in the visual arts, in the sense that Rainer's work folded the 'fetish' (usually an extraneous object) back into the idea of process through time; movement through time becomes charged in itself, shifting perception of the 'dematerialisation' of the art object into a new conception of what 'material' can be.

7
An earlier version had also been presented at Brandeis University in January 1968.

8
Video interview conducted by Wendy Perron at Yvonne Rainer's loft in 1981. Jerome Robbins Dance Division, New York Public Library.

9
Mylar® is an extraordinarily strong polyester film created through the development of Dacron® in the early 1950s.

10
Found in a letter from Rainer to Mr. Stephen Martin regarding *The Mind is a Muscle* at Brandeis dated 18 December 1967, 'Correspondence 1953–68', Box 7, Rainer archive, Getty Research Institute.

11

A notable example is Steve Paxton's *Satisfyin' Lover* (1967), in which a large group of non-dancers were directed simply to walk back and forth between the theatre wings across the stage.

12

The first 'Concert of Dance' took place on 6 July 1962, lasted for three hours and included 24 dances. Rainer described it as 'a three-hour marathon for a capacity audience of 300'. Yvonne Rainer, *Work 1961–73*, New York: NYU Press, 1974, p.8. See Sally Banes, *Democracy's Body: Judson Dance Theater 1962–1964*, Durham and London: Duke University Press, 1993, p.41 for further description of the dances.

13

Yvonne Rainer, *Feelings Are Facts: A Life*, Cambridge Mass. and London: The MIT Press, 2006, p.222.

14

*Ibid.*, p.223.

15

Y. Rainer, *Work 1961–73*, *op. cit.*, p.13.

16

*Ibid.*

17

In her autobiography Rainer notes telling Morris at a certain point in the mid-1960s to 'get out of my field' or she would have to get out of his life. He 'eased himself' out of her field, she says, with 'surprising good grace'. Y. Rainer, *Feelings Are Facts: A Life*, *op. cit.*, p.265.

18

She notes in a letter to her brother the impact that a Living Theater solo called *Tea at the Palaz of Hoon* had on her in August 1961. Y. Rainer, *Feelings Are Facts: A Life*, *op. cit.*, p.202.

19

*Ibid.*, p.203.

20

Lucy R. Lippard, *Six Years: The Dematerialization of the Art Object from 1966 to 1972*, Berkeley: UCP, 1997, p.42.

21

He continued the paragraph, 'They will discover out of ordinary things the meaning of ordinariness.' Allan Kaprow, 'The Legacy of Jackson Pollock', *Essays on the Blurring of Art and Life,* Berkeley: UCP, 1996, p.9.

22
Y. Rainer, statement accompanying *The Mind is a Muscle*, *op. cit.*

23
Gregory Battcock, *Minimal Art: A Critical Anthology*, New York: E.P. Dutton, 1968.

24
Y. Rainer, *Work 1961–73*, *op. cit.*, p.6.

25
Y. Rainer, *Feelings Are Facts: A Life*, *op. cit.*, p.253.

26
S. Banes, *Democracy's Body: Judson Dance Theater 1962–1964*, *op. cit.*, p.19.

27
*Ibid.*, p.40.

28
Kynaston McShine, *Primary Structures: Younger American and British Sculptors* (exh. cat), New York: The Jewish Museum, 1966, p.1.

29
Rainer recalls in a recent conversation with me that anybody who had work to present could contribute to these concerts early on at Judson.

30
With *Terrain*, Rainer had been the first to present an entire evening at Judson of only her own work.

31
Rainer mentions this in *Feelings Are Facts: A Life*, *op. cit.*, p.220.

32
Rainer studied almost continuously with Cunningham, taking classes between 1960 and 1967.

33
Interview with W. Perron, *op. cit.*

34
Yvonne Rainer, 'Looking Myself in the Mouth', *A Woman Who ... Essays, Interviews, Scripts*, Baltimore: The John Hopkins University Press, 1999, p.95.

35
Rainer later retracted some of her criticisms of Cage, acknowledging his important influence.

36
Truly democratic participation was to become the principle upon which
she worked for a short time in *Continuous Project Altered Daily* and *Grand
Union* in the early 1970s. Rainer said that she became frustrated with
this model of working quite quickly, however.

37
Rancière characterised it thus at the ICA, London, 9 February 2007
in a lecture based on his book, *Hatred of Democracy* (trans. Steve Corcoran),
London and New York: Verso, 2006.

38
Y. Rainer, 'Looking Myself in the Mouth', *op. cit.*, p.59.

39
This was to change with *Continuous Project Altered Daily* (1969—70),
in which she attempted to form an actual 'democratic social structure'
within the participating community in the work. Y. Rainer, *Work 1961—73*,
*op. cit.*, p.128.

40
Y. Rainer, writing on *Parts of Some Sextets* (1965), *Work 1961—73*, *op. cit.*, p.51
(first published in *Tulane Drama Review*, vol.10 no.2, Winter 1965).

41
Guy Debord, *The Society of the Spectacle* (trans. Donald Nicholson-Smith),
New York: Zone Books, 1994, p.4.

42
*Ibid.*, p.23.

43
Gilles Lipovetsky, *Hypermodern Times* (trans. Andrew Brown), Cambridge:
Polity Press, 2005.

44
Diary entry, Saturday 15 November 1952, 'Notebooks 1949—52', Box 1,
Rainer archive, Getty Research Institute.

45
As she describes it in the programme notes for *The Mind is a Muscle*.

46
In an interview I conducted with Rainer in 1998, she cited Andy Warhol's
durational films such as *Chelsea Girls* (1966) and *Henry Geldzahler* (1964)
as formative influences on her own work. She saw both films in 1966.

47
G. Debord, *The Society of the Spectacle*, *op. cit.*, p.23.

48
Letter to the organiser 'Alice', 3 May 1966, 'Correspondence 1953—68', Box 7, Rainer archive, Getty Research Institute.

49
Letter to Buchloh, 10 November 1974, 'Correspondence 1953—68', Box 7, Rainer archive, Getty Research Institute.

50
*Ibid.*

51
A group of dancers walked through the street — eyes gazing toward the floor, walking stiffly and slowly together as a unit — as a Vietnam War protest and an act of resistance to everyday activity.

52
Yvonne Rainer, statement accompanying *The Mind is a Muscle* at the Anderson Theater, March 1968.

53
Jacques Rancière, *The Politics of Aesthetics* (trans. Gabriel Rockhill), London and New York: Continuum, 2004, p.12.

54
*Ibid.*, p.13.

55
Interview with W. Perron, *op. cit.*

56
Norman M. Klein, 'Audience Culture and the Video Screen', *Illuminating Video*, New York: Aperture, 1991, p.375.

57
When interviewed in the film *Rainer Variations* (2002) by Charles Atlas.

58
As part of 'Angry Arts Week', 1967.

59
This notion must be seen in the context of Warhol's 'superstars' at the Factory in the same period.

60
Citation from the voice-over to the 1961 film *Critique of Separation* by
Guy Debord, translated into English by Ken Knabb on the website for the
Situationist International http://www.cddc.vt.edu/sionline/index.html

61
Box 1, 1949–52, is held in the Special Collection of the Research Library
at the Getty Center, Los Angeles, California.

62
Diary entry, August 1951, 'Notebooks 1949–52', Box 1, Rainer archive,
Getty Research Institute.

63
Jean Baudrillard, *Art & Artefact* (trans. Nicholas Zurbrugg), London:
Sage Publications, 1997, p.19.

64
Y. Rainer, *Work 1961–73*, *op. cit.*, p.vii.

65
As mentioned previously, this was performed in the first 'Concert of Dance'
at the Judson, July 1962.

66
It is interesting to consider Rainer's influence on contemporary French
choreographer Jérôme Bel's work *Véronique Doisneau* (2004) in this regard.
In this work, a critique of ballet in a different sense, Bel invited a dancer
from the *corps de ballet* at the Paris Opera to perform her life history
onstage, bringing her out from the abstracted mass of bodies who frame
the prima ballerina/male lead's story into the foreground as an individual
with a narrative of her own.

67
Rainer told me this in an email exchange, 18 March 2007. The mirror
is still in her New York loft.

68
Y. Rainer, *Work 1961–73*, *op. cit.*, p.vii.

69
Extract from a draft letter to 'Miss Intravaia', 1964, 'Correspondence
1953–68', Box 7, Rainer archive, Getty Research Institute.

70
Interview with Nera Dimitrijevic, *Flash Art*, March/April 1977, p.18.

71
For Wittgenstein, thought is inevitably tied to language, which is inherently social; therefore, there is no 'inner' space for thoughts to occur.

72
Ludwig Wittgenstein, *Philosophical Investigations* (trans. G.E.M. Anscombe), Oxford: Blackwell, 3rd ed., 1968, p.3.

73
Y. Rainer, 'Looking Myself in the Mouth', *op. cit.*, p.64.

74
In a 1965 performance danced to J.S. Bach's *Toccata* and *Fugue in D Minor*.

75
Letter to Ivan and and his wife Belle, 26 November 1966, 'Correspondence 1953—68', Box 7, Rainer archive, Getty Research Institute.

76
Y. Rainer, *Feelings Are Facts: A Life*, *op. cit.*, p.297.

77
*Ibid.*, p.298.

78
A. Kaprow, 'The Legacy of Jackson Pollock', *op. cit.*, p.5.

79
*Ibid.*

80
Rosalind Krauss, *The Optical Unconscious*, October Books, Cambridge Mass.: The MIT Press, 1993, p.302.

81
Bert O. States, 'Performance as Metaphor', *Afterall*, Issue 3, Spring/Summer 2001, p.66 (originally published in *Theatre Journal* 48:1, 1996).

82
Michael Fried, 'Art & Objecthood', *Art & Objecthood: Essays and Reviews*, Chicago: The University of Chicago Press, pp.148—172.

83
Henry M. Sayre, *The Object of Performance: The American Avant-Garde Since 1970*, University of Chicago Press, 1992.

84
'Rainer and several of her peers in the Judson Dance Theater and in other arts movements of the early 1960s were interested in [...] finding ways of moving (and other human actions and expressions) that would have meaning for the democratic majority, valuing the ordinary lives of ordinary people. This determination stemmed from egalitarian political principles.' Sally Banes, *Reinventing Dance in the 1960s: Everything Was Possible*, Madison, Wise: University of Wisconsin Press, 2003, p.18.

85
Rainer told me this in the interview I conducted with her in New York in 1998. Carrie Lambert-Beatty also notes Rainer's emphasis on the way the movement 'seems geared' or 'appears commensurate' in her 'Quasi Survey', reprinted in Y. Rainer, *Work 1961–73*, *op. cit.*, p.67.

86
Judith Butler, 'Performative Acts and Gender Constitution' in Michael Huxley and Noel Witts (eds.), *The Twentieth Century Performance Reader*, London: Routledge, 2002, p.120.

87
*Ibid.*

88
*Ibid.*, p.121.

89
Quote from correspondence with Sid Sachs in S. Sachs, *Yvonne Rainer: Radical Juxtapositions: 1961–2002* (exh. cat.), Philadelphia: University of the Arts, 2002, p.12.

90
J. Butler, 'Performative Acts and Gender Constitution', *op. cit.*, p.123.

91
Anthony Giddens, *Capitalism and Modern Social Theory*, Cambridge University Press, 2002, p.217.

92
J. Butler, 'Performative Acts and Gender Constitution', *op. cit.*, p.127.

93
David Graeber, 'Fetishism as Social Creativity or, Fetishes Are Gods in the Process of Construction', *Anthropological Theory*, vol.5 no.4, 2005, p.416.

94
*Ibid.*

95
*Ibid.*, p.425.

96
*Ibid.*, p.408.

97
The significance of the non-proscenium situation and the Judson gymnasium's single floor-plane has itself no doubt been overemphasised; however, as Rainer told me, 'these were the spaces that were available to us. If a theatre was available to us, we would probably have performed there.' Interview with me in New York, August 1998.

98
Selma Jeanne Cohen (ed.), *Dance as a Theatre Art: Source Readings in Dance History from 1581 to the Present*, Princeton, N.J.: A Dance Horizons Book, Princeton Book Company, 1992, p.1.

99
Rainer recollected that the tickets cost approximately $2.50 in an email interview, 18 March 2007.

100
Lyn Blumenthal and Kate Horsfield, 'Yvonne Rainer', in Y. Rainer (ed.), *A Woman Who ... Essays, Interviews, Scripts, op. cit.*, p.65.

101
Interview by Maricala Moyano, *The Washington Post*, Sunday 5 June 1966, p.34.

102
Rainer has since said that she herself 'was the sort of person who would boo at dance concerts'. Interview with W. Perron, *op. cit.*

103
Letter to Ivan, 1 January 1966, 'Correspondence 1966', Box 7, Rainer archive, Getty Research Institute.

104
Rainer recalled one audience member using the wooden slat and a handkerchief to wave a flag of surrender during one version of *Trio A*. This incident is recounted in Y. Rainer, *Feelings Are Facts: A Life, op. cit.*, pp.269—71.

105
S.J. Cohen (ed.), *Dance as a Theatre Art: Source Readings in Dance History From 1581 to the Present, op. cit.*, p.6.

106
It is worth noting that in Europe Rudolf Laban and others were simultaneously proposing similar ideas.

107
Isadora Duncan, 'The Dancer of the Future', M. Huxley and N. Witts (eds.), *The Twentieth Century Performance Reader*, *op. cit.*, p.175.

108
See Charles Atlas's film *Rainer Variations* (2002), an excellent parody juxtaposing Graham's method with Rainer's style.

109
Extract from letter to 'Miss Intravaia', *op. cit.*

110
Yvonne Rainer, '*Trio A*: Genealogy, Documentation, Notation', *Dance Theater Journal*, vol.20 no.4, 2005, p.7.

111
From C. Lambert-Beatty's forthcoming monograph on Rainer for the October Books series, Cambridge, Mass. and London: The MIT Press.

112
Michel de Certeau, *The Practice of Everyday Life* (trans. Steven Rendall), Berkeley: UCP, 1988, p.98.

113
Excerpts from the statement accompanying *The Mind is a Muscle* at the Anderson Theater, March 1968.

114
Cue sheet seen in a notebook labelled '*The Mind is a Muscle*', Box 3, Rainer archive, Getty Research Institute.

115
B.O. States, 'Performance as Metaphor', *op. cit.*, p.67.

116
In the extended reference here, he uses the analogy of how a 'film director' 'treats a strip of film' so that behaviour can be 'rearranged or reconstructed'. *Ibid.*, pp.73–74.

117
Discussing the Kunsthalle Wien exhibition 'A Baroque Party' (2001), in which Rainer's work was included, art historian Peggy Phelan and curator Sabine Folie specifically raised the question of Rainer's relationship to the Baroque. Folie describes the pivotal concept of the *Theatrum Mundi* as,

'not just theatre, but rather a celebration of a radical "being in the world"'.
Correspondence with Rainer, 'Book/Correspondence', Box 31, Rainer archive,
Getty Research Institute.

118
Letter to Ivan and Belle, 26 November 1966, *op. cit.*

119
Marion Sawyer, 'The 60s: A Remarkable Decade', *Chelsea Clinton News*, 15
January 1970, p.6.

120
C. Lambert-Beatty pinpoints the exact image — a photograph by Eddie Adams
broadcast on NBC — that is likely to have been the one that Rainer referred
to when she said she had seen 'a Vietnamese shot dead on TV'. It was related
to the notorious My Lai massacre, which took place on 16 March 1968, and
which became emblematic of the disaster of the Vietnam War. The incident
remained unknown to the American public until the autumn of 1969,
when a series of letters by a former soldier to government officials forced
the US Army to take action. C. Lambert-Beatty's forthcoming monograph
for October Books, *op. cit.*

121
Reviewed by Jacqueline Maskey, *Dance Magazine*, March 1967, p.83. 'Reviews,
Other, 1967', Box 36, Rainer archive, Getty Research Institute.

122
Clive Barnes, *The New York Times*, 3 February 1967, p.34, 'Reviews, Other,
1967', Box 36, Rainer archive, Getty Research Institute.

123
Marcia B. Siegel, 'Smut and Other Diversions', (source not indicated),
'Reviews, Other, 1967', Box 36, Rainer archive, Getty Research Institute.

124
George Bray, 'Yvonne Rainer, Post-Modern Dancer, Is a Riddle in Movement'
*The Day*, New London, Conn., Tuesday 15 July 1969, p.15, 'Reviews, Other,
1967', Box 36, Rainer archive, Getty Research Institute.

125
Interview with W. Perron, *op. cit.*

126
J. Butler, 'Performative Acts and Gender Constitution', *op. cit.*, p.121.

127
Y. Rainer, 'Interviews Ann Halprin', Richard Schechner and Michael Kirby
(eds.): *Tulane Drama Review*, *op. cit.*, p.143.

128
Letter to Ivan, 1 January 1966, *op. cit.* In a previous letter, not long before this one, she had recommended that her brother give up his job in order to 'find himself', suggesting that he could have the allowance her mother was sending her.

129
Y. Rainer, *Feelings Are Facts: A Life*, *op. cit.*, p.24.

130
Rainer lists attending a Zionist Socialist youth-group summer camp as one of her formative childhood experiences. Y. Rainer, *Work 1961–73*, *op. cit.*, p.2.

131
Letter to Ivan, 25 August 1961. Y. Rainer, *Feelings Are Facts: A Life*, *op. cit.*, p.211. As 1961 was the year the Berlin Wall was built, Rainer added, 'It is hard to know what to do' — whether to protest or carry on in the face of the 'horror' that was in the newspapers.

132
Y. Rainer quoted in 'The Performer as a Persona: An Interview with Yvonne Rainer', Willoughby Sharp and Liza Bear, *Avalanche*, New York, no.5, Summer 1972, p.52.

133
Y. Rainer, *Work 1961–73*, *op. cit.*, p.67.

134
Rainer discussing *Trio A*. *Ibid.*, p.66.

135
Randy Martin, 'Dance and Its Others: Theory, State, Nation & Socialism', in Andre Lepecki (ed.), *Of the Presence of the Body: Essays on Dance and Performance Theory*, Middletown, CT: Wesleyan University Press, 2004, p.62.

136
Marx quoted in A. Giddens, *Capitalism and Modern Social Theory*, *op. cit.*, p.230.

137
*Ibid.*

138
Not in an indeterminate way, as was the case in Steve Paxton's development of 'Contact Improvisation', a dance technique in which points of physical contact provide the starting point for movement and improvisation.

139
These instructions are reproduced in Y. Rainer, *Work 1961—73*, *op. cit.*, p.100.

140
Thursday 17 May 1951, 'Notebooks 1949—52', Box 1, Rainer archive, Getty Research Institute.

141
Tuesday 25 November 1952, 'Notebooks 1949—52', Box 1, Rainer archive, Getty Research Institute.

142
Y. Rainer, *Work 1961—73*, *op. cit.*, p.64.

143
*Ibid.*, p.67.

144
Discussion at Tanzquartier Vienna, November 2006, held as a part of the performance and lecture programme Wieder und Wider, organised by Barbara Clausen and Achim Hochdörfer, MUMOK/Tanzquartier Vienna.

145
Originally trained as a stonemason in his native Italy, her father, after emigrating to the US, first became a house painter and contractor on the West Coast, and later a small-scale property developer.

146
Letter to Ivan, 1 January 1966, *op. cit.*

147
J. Rancière, *The Politics of Aesthetics*, *op. cit.*, p.43.

148
*Ibid.*

149
*Ibid.*, p.45.

150
Y. Rainer, *Work 1961—73*, *op. cit.*, p.67.

151
Y. Rainer, *Work 1961—73*, *op. cit.*, p.51.

152
Letter to Ivan and Belle, 26 November 1966, *op. cit.*

153
Thorstein Veblen, *Conspicuous Consumption*, London: Penguin Books, 2005, p.21.

154
*Ibid.*, p.22.

155
Y. Rainer, *Work 1961–73*, *op. cit.*, p.64.

156
G. Debord, *The Society of the Spectacle*, *op. cit.*, p.4.

157
D. Graeber, 'Fetishism as Social Creativity', *op. cit.*, p.432.

158
J. Rancière, *The Politics of Aesthetics*, *op. cit.*, p.43.

159
Y. Rainer, 'Looking Myself in the Mouth', *op. cit.*, p.62.

160
Y. Rainer, '*Trio A*: Genealogy, Documentation, Notation', *op. cit.*, p.3.

161
Yvonne Rainer interview in Nicholas Zurbrugg (ed.), *31 Interviews*, Minneapolis: University of Minnesota Press, 1994, p.295.

162
*Ibid.*

163
Y. Rainer, '*Trio A*: Genealogy, Documentation, Notation', *op. cit.*, p.7.

164
See C. Lambert-Beatty, 'Moving Still: Mediating Yvonne Rainer's *Trio A*', *October*, no.89, Summer 1999 and Y. Rainer, *Work 1961–73*, *op. cit.*, p.68. Rainer said this after noting 'Dance is hard to see. It must either be made less fancy, or the fact of that intrinsic difficulty must be emphasised to the point that it becomes almost impossible to see.'

165
Y. Rainer, '*Trio A*: Genealogy, Documentation, Notation', *op. cit.*, p.4.

166
*Ibid.*

167
The televised performance was for PBS in the US, danced by Sarah Rudner
from Twyla Tharp Dance, Bart Cook of the NYC Ballet, and an untrained
dancer named Frank Conversano. Y. Rainer, 'Trio A: Genealogy,
Documentation, Notation', *op. cit.*, p.4.

168
Nicholas Bourriaud, *Relational Aesthetics* (trans. Simon Pleasance and
Fronza Woods), Paris: Les Presses du Réel, 2002, p.14.

169
*Ibid.*, p.9.

170
*Ibid.*, p.13.

171
J. Rancière, *Hatred of Democracy*, *op. cit.*, p.61.

172
Marcel Mauss, *The Gift*, London: Routledge, 2001.

173
This stands in contrast to the way in which the dematerialised practices
of artists such as Sol LeWitt or Daniel Buren (wall drawings sold as sets of
instructions) or the anti-form works of Robert Morris were shown and sold
in commercial galleries at the time. Even when she began to make films,
Rainer was horrified at the idea of her work entering the market. In a
letter to Benjamin Buchloh in 1974, she wrote, 'I am having to face certain
hard facts now that I am being handled by Castelli-Sonnabend [...] A print
of *Film About a Woman Who* ... is now a speculative commodity. The thought
of it belonging to a private collector to be shown in his living room is
horrifying to me. [...] I have always made a public art to be viewed by people
sitting together in a public space.' Letter to Buchloh, 10 November 1974.
'Correspondence 1953–1968', Box 7, Rainer archive, Getty Research Institute.

174
Y. Rainer, *Work 1961–73*, *op. cit.*, p.68.

175
Letter to Ivan and Belle, 31 August 1961, 'Correspondence 1953–68', Box 7,
Rainer archive, Getty Research Institute.

176
Labanotation is a system of movement notation that is also used to record
dance choreography. Invented by Rudolf Laban, it is one of the two main
systems of movement notation used in Western culture. Labanotation
uses abstract symbols to define, variously: the direction of the movement,

the part of the body doing the movement, the speed of the movement, the time it takes to execute the movement, and so on.

177
Y. Rainer, '*Trio A*: Genealogy, Documentation, Notation', *op. cit.*, p.7.

178
In email correspondence, 18 March 2007.

179
G. Lipovetsky, *Hypermodern Times, op. cit.*, p.32.

180
It is fruitful to compare this dilemma with its resolution in the work of Tino Sehgal, an artist of the subsequent generation whose 'editioned' live works are disseminated, and sold, by the artist via verbal means in a manner akin to the 'oral tradition'. *This is Propaganda* (2002) and *This Is So Contemporary* (2004), for example, are sets of instructions to be interpreted by actors playing the roles of museum guards that effect challenging disturbances of what at first appears to be a conventional distribution of people in the roles of staff and spectators in the gallery. Sehgal's work was formed in part from his participation in Jérôme Bel's dance company. Bel, like his peer and collaborator Xavier Le Roi, notes the influence of Rainer's work, especially *Continuous Project Altered Daily.* Sehgal's work accelerates the market's logic, affirming that the temporary quality of the gesture is enough now to position it as being radical, and thus for the collector to purchase it as art. The work of its execution, undertaken by hired interpreters cast and rehearsed by the artist, and its status as artwork are separated by economics. In fact, this separation helps Sehgal to maintain the authority of authorship; he or an appointed bearer of the instructions maintains the works' correct forms.

181
N. Zurbrugg (ed.), *31 Interviews, op. cit.*, p.295.